THE PRINT. MAKING BOOK

VANESSA MOONCIE

PROJECTS AND TECHNIQUES IN THE ART OF HAND-PRINTING

First published 2013 by
Guild of Master Craftsman Publications Ltd
Castle Place, 166 High Street, Lewes,
East Sussex BN7 1XU

Text and illustrations © Vanessa Mooncie, 2013
Copyright in the Work © GMC Publications Ltd, 2013

ISBN 978 1 86108 921 2

Publisher Jonathan Bailey
Production Manager Jim Bulley
Managing Editor Gerrie Purcell
Senior Project Editor Dominique Page
Editor Susie Behar
Managing Art Editor Gilda Pacitti
Art Editor Rebecca Mothersole
Designer Simon Goggin
Photographer Rebecca Mothersole

Colour origination by GMC Reprographics
Printed and bound in China

CONTENTS

INTRODUCTION

Print making has come to occupy a position in society and culture that is unique due to its versatile and multifaceted application and the rich variation of finished products or styles it can achieve.

Print making was originally used as a means of communication, and was utilized as a fast and effective way of reproducing information to pass on to a larger public or a small, dedicated audience.

Later, artists saw the aesthetic potential of the print-making process and quickly began to establish the rich variety of styles, forms and different techniques that apply to print making today, making original prints and producing limited editions of their work.

A hand-printed piece, even in multiple form, is an original work of art, as each one will vary slightly due to the nature of the printing process.

In this book I explore the rich tableau of various print-making techniques and the styles associated with those different disciplines. I hope to give the creative practitioner or hobbyist the skills, knowledge and tools required to discover the exciting and vibrant world of print making, and support the development of style and design choices.

By following the print-making projects, each laid out in easy-to-follow step-by-step instructions, you can adorn the walls of your home with hand block-printed wallpaper, create cushion covers and tea towel designs and fill your wardrobe with floral scarves and garments.

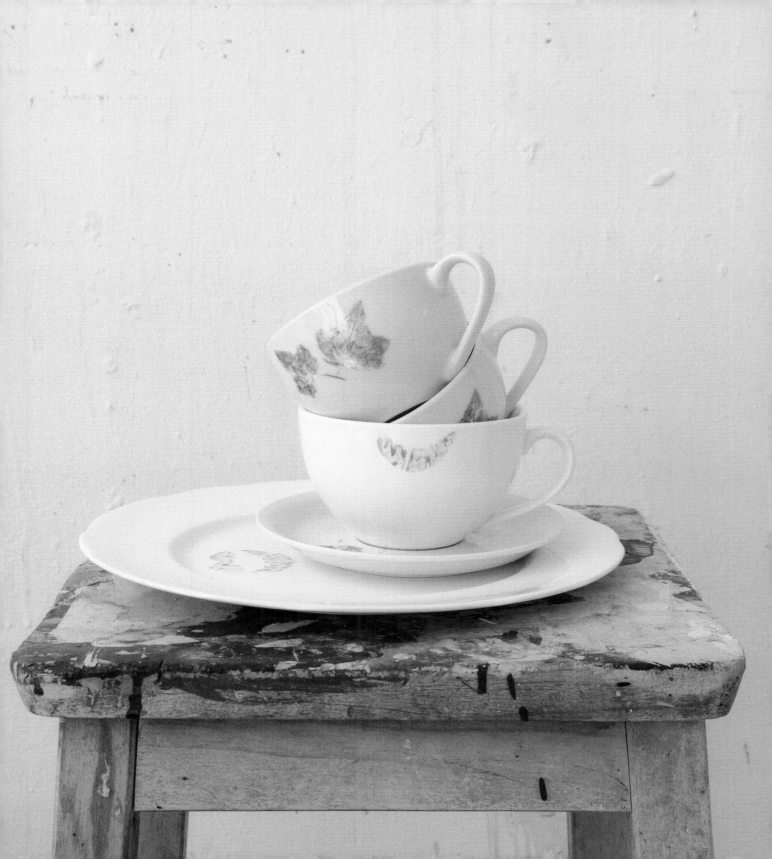

THE WORKSPACE

The rich variety of print making techniques detailed in this book can be tailored to suit most workspaces; they do not have to take place in an airy, light-filled studio. I have used the kitchen, bathroom and even the garden to achieve the projects I have featured.

The key to success and satisfaction within any given project lies in the preparation and careful thought that you give to the task in hand.

Ideally you will need a good-sized table or work surface to work on, but the floor can be used as well if space is tight. Be prepared to cover the surface on which you are working with brown paper or newspaper to catch any spillages. Having a sink in the room or nearby is very handy to wash the equipment or clean up, but a large plastic tub can be filled with a little water and carried to the workspace. Another consideration is to be aware of colour changes in changing light; to get the best result, it is important to work in as much natural light as possible.

However, always bear in mind that print making is fun and the method and learning process is half the enjoyment. Also, many of the projects give you repeated opportunities to fine-tune your designs, your technique and the effect of your finished pieces.

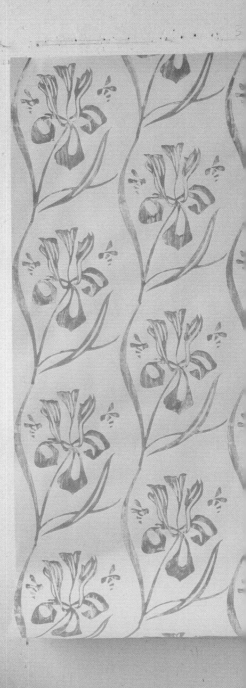

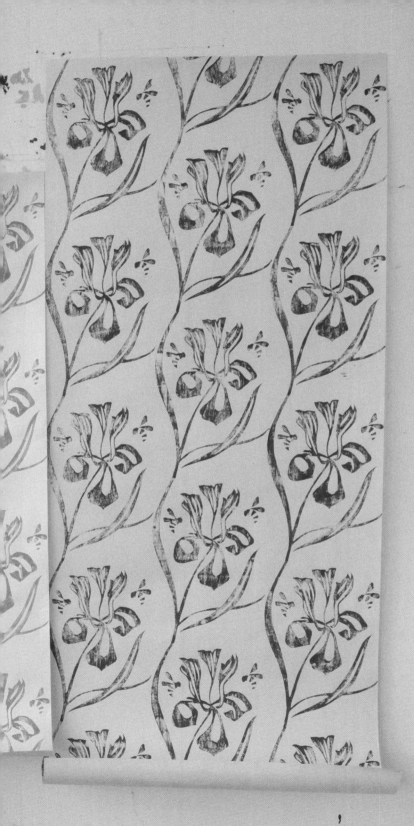

11

GENERAL SUPPLIES

CUTTING EQUIPMENT

CRAFT KNIFE AND UTILITY KNIFE

You will need a craft knife for cutting stencils. The knife should have a sharp blade, which must be replaced when worn. A blunt blade will tear the fibres of the paper so the lines will not be crisp. For cutting heavier materials, it is best to use a utility knife.

PAPER CUTTER AND SCISSORS

A paper cutter is ideal for cutting large sheets, leaving a straight edge. Keep a pair of scissors each for fabric and paper; do not use fabric scissors for cutting paper, as this wears down the blade.

CUTTING MAT

A cutting mat is used to protect the surface you are working on when cutting, as well as preventing the blade of the knife from becoming blunt. A self-healing mat often has gridlines to facilitate cutting a straight line. When a knife goes through the paper or card and cuts into the mat, the surface bonds together so that it becomes smooth again.

METAL RULER

A ruler is not only used for measuring but also for providing a straight edge to cut paper down to size when producing several editions of one design. A metal ruler is best to use with a craft or utility knife.

PAINTING EQUIPMENT

BRUSHES

A selection of paintbrushes in an assortment of sizes is useful for various tasks. As well as painting, they are used for applying glue and varnish. A small round brush has long bristles and a pointed tip and is suitable for intricate details. A 'flat' is a wide brush with a narrow edge, for both broad and fine lines. A 'mop' is a larger brush with a rounded end and is great for applying varnish. The stipple brush has a flat head; the pigment is applied by tapping the ends of the bristles onto the surface. Generally, a mushroom brush is used for cleaning vegetables; however, the soft bristles make it ideal for use in print making.

BRAYER

A brayer, or hand-roller, is used to apply a coat of ink or paint in an even layer over a surface. The roller is mounted on a rod that is attached to a handle. Brayers are available in various sizes and should be chosen according to the size of the work. The very large rollers have a double handle for use on extensive pieces. Rubber brayers are used for monoprinting and relief printing. A sponge roller is used to apply an even coat of pigment to fabric, as in the Book Cover project on page 113.

PAINT PALETTE

A large plate or other non-porous surface can be used as a palette. I happen to use a piece of glass that I took from an old refrigerator. The glass is thick with smooth edges and it is easy to keep clean.

ICE LOLLY STICK

Just as my mum held on to ice lolly sticks to use as labels for her garden plants, I keep them now for printing. They are handy for mixing colours and spreading paint.

SURFACE PROTECTION

Newsprint, newspaper and brown paper can all be used to cover a surface to protect it from the inevitable spillages.

APRON

I always wear an apron when printing. However careful I am, I still manage to add a new splash of colour each time to my once crisp, white pinny.

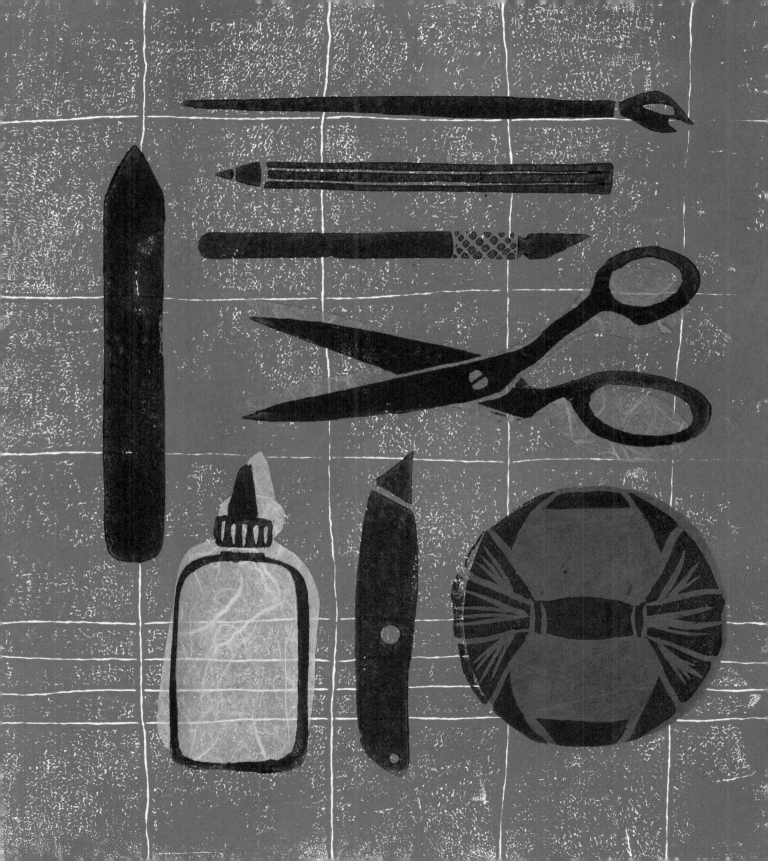

DRAWING EQUIPMENT

A soft pencil is ideal for transferring designs when carbon paper is not available. Artwork can also be drawn directly onto the surface of a lino or wood block using a pencil or felt-tip pen. A ballpoint pen or pencil is handy for working on a drawn monoprint, transferring the ink in a similar way to a making a carbon copy. When cutting separate stencils for printing in multiple colour ways, coloured pencils or felt-tip pens are useful for planning the design.

BURNISHING TOOLS

Several inexpensive tools can be used as a printing press to transfer an image to paper. The traditional tool is a baren, which has a smooth surface that is rubbed over the back of the paper, transferring the ink from the block. A bone folder has a pointed tip for scoring paper, a rounded end and a smooth, flat surface for burnishing. The back of a wooden spoon is ideal for printing projects and is easily accessible. On smaller projects, such as the Eraser Stamps on page 39, a finger is the perfect burnishing tool.

PAPER

There is a wide choice of weights and textures that are perfect for all kinds of print making. Archival or acid-free paper has a neutral or basic pH of 7 or slightly greater. The pH measures the acid or alkaline of a solution on a scale of 0 to 14. Most papers are made from wood, which contains a chemical compound called lignin. Lignin turns yellow and deteriorates with age. Archival paper is made from fibres of plant or plant-based materials and has had the active acid pulp and lignin removed, therefore it is perfect for projects that you want to preserve.

CARBON PAPER

Carbon paper is used to transfer artwork to a surface by laying the carbon side down and marking the back of it.

TRACING PAPER

A drawing on tracing paper in soft pencil can be transferred in the same way as carbon paper by turning the tracing paper and going over the markings that show through on the reverse side.

CARD

Card is used for registering a print. Cut greetings cards or postcards into strips, butt up the original, straight edge of the card against the printing surface and tape it down to provide a marker. This will enable additional colours to be printed accurately as well as several editions of an artwork to be produced.

ACETATE

Acetate is a multi-purpose clear film. It can be applied as a transparency for photosensitive printing, drawn and painted on and used to transfer a design onto paper or fabric, and it is also ideal for registering multi-coloured images in screen printing. Usefully, it can be cleaned and re-used.

ADHESIVES

PVA (polyvinyl acetate) can be used neat or diluted with water and it dries clear. Spray mount is applied in even coats and allows for repositioning but must be used in a well-ventilated area. Superglue is useful to have; I prefer the gel, which works on porous as well as non-porous surfaces. Glue sticks are great for children to use; they dry smoothly and, providing the lid is replaced after use, last a long time.

OTHER USEFUL ITEMS

IRON AND IRONING BOARD

Textile paints will require fixing with an iron. Make sure it is set to the highest heat suitable for the fabric and use a dry cloth between the plate of the iron and the printed material. An iron is also used to fuse freezer-paper stencils to fabric.

TAPES

Packing tape is very useful. I use it for masking off the edges of a screen-printing frame to prevent ink seeping through to the paper or board. Masking tape can also be used for this job as it comes in various widths. For temporary taping of artwork, use low-tack, acid-free tape.

BAKING TRAY

A baking tray is used in the Shrinkable Plastic project on page 147 to shrink the pieces in the oven. It is also employed as a mould for the gelatine plate that is used in the Place Mats project on page 101. As baking trays are available in different sizes, it is possible to produce a gelatine plate in various dimensions.

CONTAINERS

Empty ice-cream containers can come in very handy when working on small printing projects. I use photographic trays, which come in different sizes, when working on a cyanotype print (see pages 122 and 127) and for developing solar plates (see page 133). Plastic storage trays are ideal and available in various depths and sizes.

SPOONS

Keep a couple of old teaspoons to hand in the workspace, as they are useful for scooping printing inks onto the palette or screen as well as adding printing medium to mix with the colours.

SEWING TOOLS

Dressmakers' pins are great for attaching an intricate stencil to fabric for sun printing. The stencil needs to be flat against the surface and, where masking tape isn't always ideal, pins can be used instead without obstructing the design. A few basic sewing tools, such as needle and thread, will provide you with the means to turn your printed fabric into a functional piece of art.

CLEANING MATERIALS

Keep paper towels and toilet tissue to hand to blot or wipe up a spillage. I have various old tea towels that I use to dry my printing tools. I cut up clean, old cotton T-shirts to dust glass or protect printed fabric when it is ironed. Sponges, large and small, are useful to wash screens and equipment. A soft brush, such as a shoe-polish brush, is great for cleaning up solar plates after printing, and a nylon bristle brush is good for removing residue ink from a screen. Chamois leather is very absorbent and ideal for drying off a screen if you are eager to carry on printing. Newsprint and newspaper can also be used to absorb excess water.

RELIEF PRINTING

Relief printing is a process used to repeat a pattern or design by carving into a material - traditionally wood - coating with a colour and transferring it to another surface. This type of printing has been used for many centuries. There is evidence that the Sumerians (*c.* 4000 BC) carved cylindrical seals in stone, which were then decorated with pictorial designs and text and rolled over wet clay to leave an impression. The Olmec civilization in Mexico (*c.* 1500-200 BC) used baked clay cylinders to print engraved symbols. Printing on paper originated soon after its invention in China in the second century AD. Early prints were used to depict religious teachings, but later secular imagery and text were introduced that were carved into wood. Multiple layers of woodcuts printed onto silk or paper produced detailed and colourful images. Relief printing in Europe did not develop until several centuries later.

Any material that has a raised surface can produce a relief print. Engraving and carving tools are used to cut into lino, wood or vinyl. The design or text is carved in reverse to leave a positive image when printed. The surface of the material that has been cut away will remain unprinted. For a design in multiple colours, separate blocks are cut for each colour. Alternatively, a single block can be carved into for each colour printed. This process is known as 'reduction'. The carved block is coated with ink, using a roller to cover it evenly. Paper is placed over it and burnished using a baren or the back of a wooden spoon. Objects can also be used to produce interesting relief prints, such as leaves, string, cardboard and metal.

TOOLS AND MATERIALS

CUTTING TOOLS

Cutting tools are available in a variety of shapes and angles, but rather than buying an inexpensive set it is better to purchase just two or three good-quality tools. Traditional wood-cutting tools can be used on lino, as well as specific lino-cutting tools. When choosing a tool, make sure the handle fits comfortably in the palm of your hand. Starting at $\frac{1}{16}$in (1mm), the 'V' gouges create a narrow, defined line and the 'U' gouges produce a curved line. The wider 'U' gouges are useful for clearing large areas. The contour knife has a sharp point and edge. The blade is at a 45-degree angle and is used for cutting lines and delicate areas of a design. The tools should be kept sharp using a special sharpening stone.

SAFETY

When using cutting tools, always keep your fingers behind the work and turn the piece you're cutting rather than the tool.

BENCH HOOK

A bench hook is a wooden or plastic board with a raised edge along the top that lino or wood can rest against. A lip underneath hooks onto your work surface, enabling it to stay steady as you carve.

RUBBER BRAYER

A brayer is a hand-roller used to apply an even layer of ink or paint. It is mounted on a rod that is attached to a handle. Rubber brayers are used for relief printing and are available in various sizes. For very large printing projects, you can get a brayer that has a double handle.

CARVING MATERIALS

LINO

Lino comes in different sizes and colours. It needs heating over a radiator or hotplate to soften the surface for ease of carving. Artists' lino is widely available, often mounted on wood, and is easy to cut without heating.

WOOD

Wood engraving uses hardwood blocks from trees such as box, maple, cherry and sycamore. It is taken from the end grain and is harder to carve into than softwood, taken from spruce and pine, which is not suitable for detailed work. Woodcuts are performed on blocks taken from the side grain. Soft Japanese plywood is ideal, as it has a smooth surface and can be drawn onto directly.

SOFTCUT PRINTING BLOCK

Softcut has a very smooth surface, making it easy to carve. Both sides can be cut. It has a smooth, shiny side and a textured matt side. It has a creamy-white surface, which makes it easy to see pencil lines.

JAPANESE VINYL

Japanese vinyl block is double-sided and has a smooth surface. It is ideal for water-based inks. The soft surface of the block makes it easier to cut into than lino, requiring less pressure to be applied. It is flexible and does not chip or crack. The black core of the vinyl is revealed as you carve, making it easy to see where you have worked.

VEGETABLES

Root vegetables are great for printing simple designs. They are easy to carve into with a kitchen knife or lino cutters. However, they don't keep for very long.

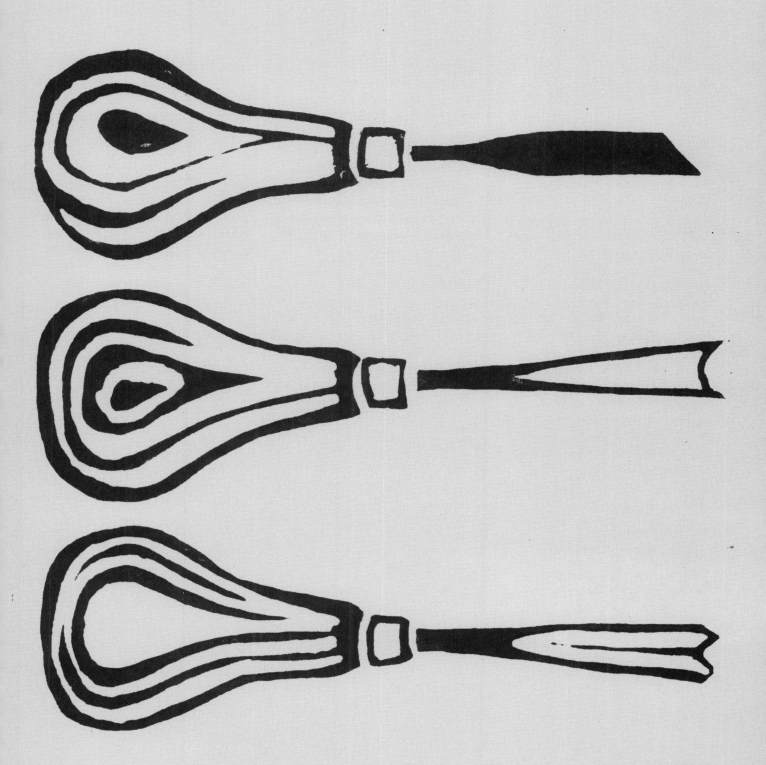

ERASERS

Erasers are perfect for making small stamps. They can be drawn onto directly and are easy to cut with lino tools. Vinyl erasers are preferable because they are particularly smooth and don't crumble as you carve.

PAPER

A good print making paper can absorb plenty of ink and withstand being soaked without losing shape or tearing. There are many types of paper to choose from and they can create quite a different effect when printed on. Cartridge paper, for instance, has a smooth surface, whereas Bockingford paper is textured, so can produce a mottled effect. Fine printing papers are made with 100% cotton fibres. Japanese papers are often made with kozo (mulberry bark) and are ideal for relief printing. Lining paper is traditionally used for covering imperfections on the walls before hanging the more expensive wallpaper. There are different grades available, ranging from budget to quality lining paper. For the Wallpaper project on page 44, I used a budget lining paper because the paint used is emulsion, which is quick to dry, so the paper won't cockle as you print. However, for the other projects, it is advisable to use a quality printing paper.

PAINT
CERAMIC PAINT

This is used for the Table Setting project on page 35 to print with leaves and a potato on china cups and saucers. Available in a wide range of colours, including metallic shades, some ceramic paints can be used on glass and porcelain, as well as china. Ceramic paint often comes in pen form, with various tip widths available for different applications. Some ceramic paints will need to be oven-baked to fix the colour, but others can be left just to air dry.

EMULSION

Emulsion paint is used to print the Wallpaper on page 44. This paint does dry fairly quickly, so it is best to work fast to avoid the printing block sticking to the paper. With so many brands and colours to choose from, the printed wallpaper can be matched with any interior decor.

INK

In this chapter, both oil and water-based block-printing ink is used. The water-based ink is easy to clean but cannot be used on woodcuts because it can cause the wood to swell.

GRAPHITE STICK

A graphite stick is ideal for rubbing over a woodblock as you carve. This will make it easier to define the areas that have been cut away, especially when working on detailed designs. Use the side of the graphite, rather than the tip, to get an even covering.

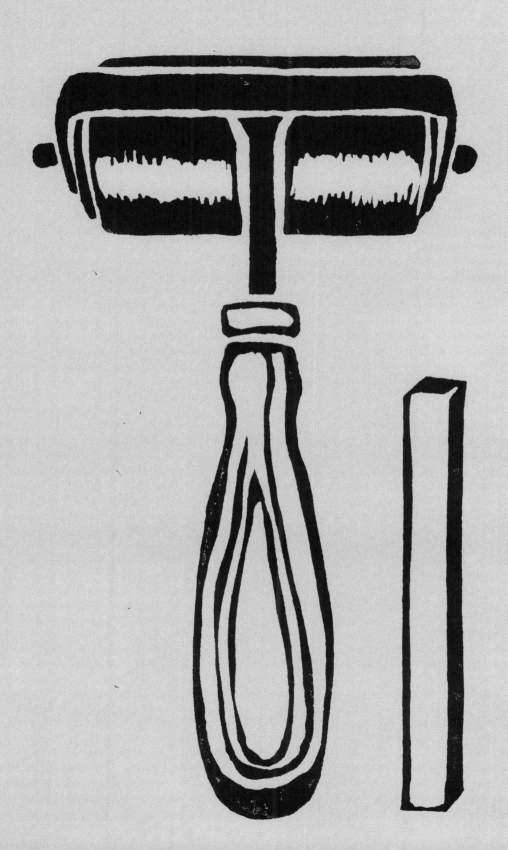

WOODCUT

A simple woodcut design can be enhanced with 'Chine collé', which is a technique of applying thin paper shapes during the printing process. The choice of papers and ink colours can produce an endless variety of woodcut prints.

TEMPLATE

TROUBLESHOOTING

- Make sure that the cutting tool is sharp enough to produce a clean line and to prevent the wood splintering.

- Coloured tissue paper for the Chine collé will tend to fade or bleed. I recommend Japanese papers for this method.

- If you find the ink has transferred onto areas that you've cut away, you may need to carve out a little more. A proof print on less expensive paper will allow you to check if the block needs working into before using the Chine collé and specialist artists' papers.

INSTRUCTIONS

TRANSFERRING THE TEMPLATE

1: Copy the template on page 23, enlarging as required, or use your own artwork. Using a soft pencil, trace your design. Place the traced artwork face down on the wood and secure in place with masking tape to prevent it slipping. The artwork on the woodcut block will appear in reverse; this is especially important to remember when text is being used in the design. Use a ball-point pen to draw over the markings showing through the back of the tracing paper to transfer the lines made by the soft pencil onto the wood. Alternatively, you can slip carbon paper between the artwork and the wood before drawing over the design.

CUTTING THE DESIGN

2: Place the wood on the bench hook. Using the cutting tools, cut away the areas that are in white on the template – these are the areas of the design that will not be printed. Take your time when cutting, turning the wood block instead of the tool and keeping your fingers behind the work to avoid injury. Use the contour knife to cut and clear the tricky angles, the V-shaped tool for the delicate lines and the U-shaped gouge for the larger areas. Brush away any residue. Rub the graphite stick over the woodblock as you work to define the areas that have been cut away. (This technique is particularly helpful when working on a very detailed project.) Try not to gouge into the wood deeply; carve away a little at a time to produce an area that won't be printed.

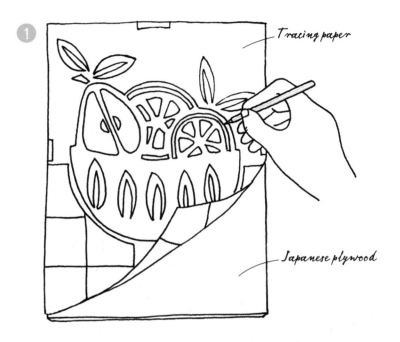

Tracing paper

Japanese plywood

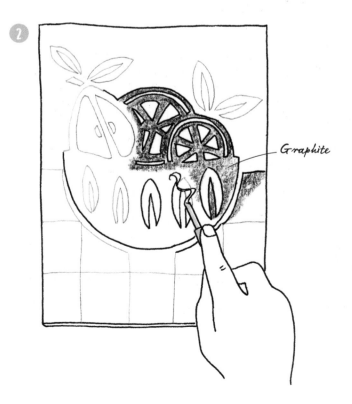

Graphite

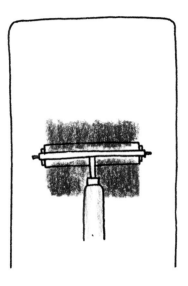

PRINTING

3: Squeeze a small amount of oil-based ink onto the palette and roll the brayer through it until it is evenly coated. Roll a thin layer of ink over the surface of the woodblock. Wipe away any excess ink with a dry cloth. Do not use water since it can distort the wood.

4: Take a proof of the block first. This is a trial piece where you can check the quality of the print (see Troubleshooting, page 23). Lay the paper over the inked woodcut and smooth it down. Roll a clean, dry brayer over the back of the paper. Lift the paper at the corner to check the print. If necessary the block can be touched up with more ink or worked into a little more with the tools. If you wish, you can now add fine coloured paper to your print using the Chine collé technique described overleaf.

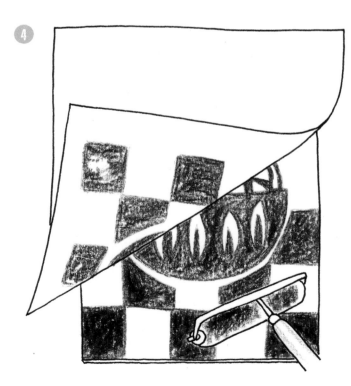

CHINE COLLÉ

5: You can take the Chine collé shapes from the template or create your own. The lines can be traced directly onto the paper if it is thin enough. If the paper is too dense to see through, use tracing paper to transfer the design. Remember that the image on the block is the reverse of the finished print.

6: Roll the ink over the block ready for printing and spray the adhesive on to the back of the cut-out Chine collé. Use tweezers to position the papers onto the block with the sticky side facing up.

7: Place the printing paper over the woodcut and smooth it down. Use the dry brayer to roll over the back of the paper, transferring the ink and the coloured papers. Carefully lift the paper at the corner to check the print and see if the Chine collé papers have adhered before moving your finished print to one side to dry.

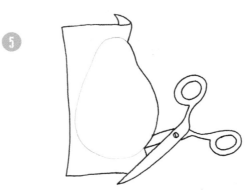

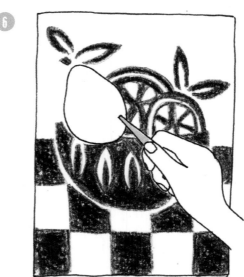

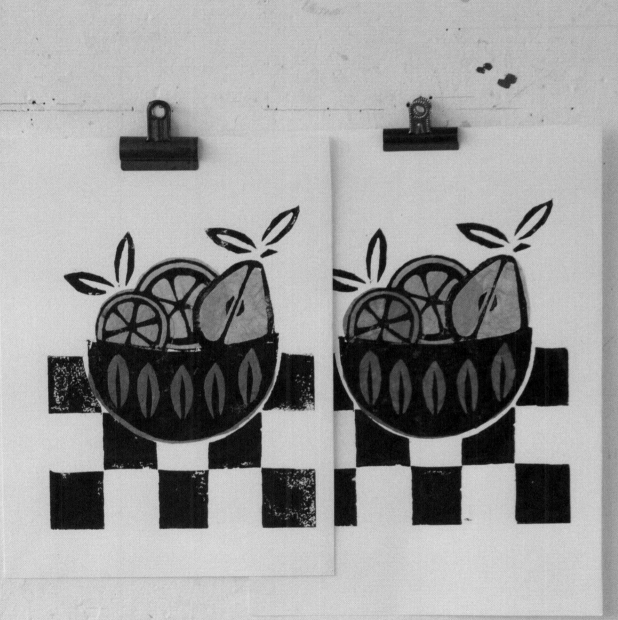

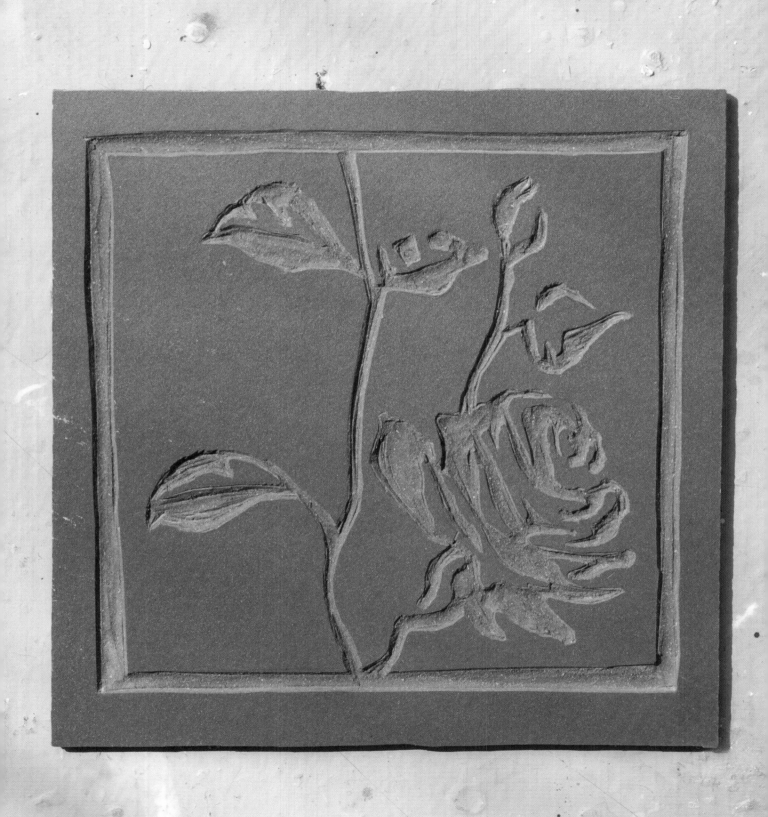

LINO PRINT

Lino is inexpensive and easy to use, as it is soft enough to be cut into. For more detailed designs, try using Japanese vinyl; designed for relief printing, it is even softer.

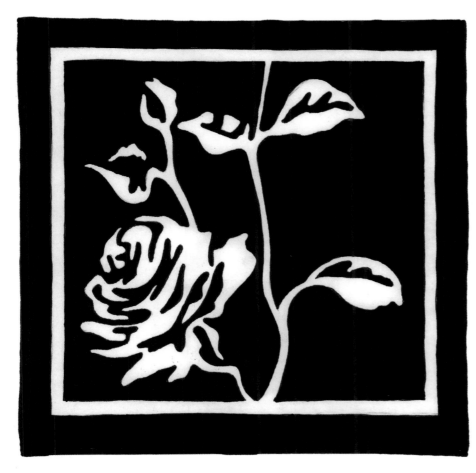

TEMPLATE

TOOLS AND MATERIALS

- 2 pieces 6 x 6in (15 x 15cm) easy-cut lino blocks or Japanese vinyl
- Pencil or felt-tip pen
- Tracing paper
- Carbon paper
- Card, such as off-cuts of mount board or packaging
- U- and V-shaped lino-cutting tools
- Bench hook
- Masking tape
- Lino/block printing ink
- Paintbrush
- Rubber brayer
- Paint palette
- Medium- to lightweight paper
- Baren or wooden spoon
- Cloth

TROUBLESHOOTING

- If you can't see the lines of your design clearly on the lino, draw over them with a marker pen or felt-tip before you start. Remember to cut the areas that are white on the template.
- If you find it difficult to cut the lino, you may be using a blunt tool. The cutting tool must be sharp to work properly and cut clean lines.
- If your print is faint or patchy, try rolling some extra ink onto the lino then continue burnishing with the brayer.

INSTRUCTIONS

TRANSFERRING THE DESIGN TO LINO

1: Copy the template on page 29, enlarging as required, or use your own artwork. The design can be drawn directly onto the lino using a felt-tip pen or a pencil, or transferred by copying it onto tracing paper. The printed artwork will appear in reverse, which is particularly important to remember when text is being used in the design. Place the traced artwork face down on the lino and slip carbon paper, carbon-side down, between the tracing paper and the lino. Draw over the outline on the back of the tracing paper with a pencil.

CUTTING THE DESIGN

2: Place the lino onto the bench hook. Using the cutting tools, cut away the white areas on the template. These are the areas of the design that will not be printed. Take your time when cutting and turn the lino block instead of the cutting tool. Make sure you keep your fingers behind the work to avoid injury. Use a paintbrush to brush away any lino residue.

REGISTRATION

3: Place the paper onto the surface where you will be printing. Cut rectangles from the card and, using masking tape, stick two lengths against each corner to mark where each piece of paper should be placed. Lay the lino centrally inside the markers, taking measurements if required, and cut another set of rectangles to mark each corner of the lino block. This will provide you with a guide for each print you do.

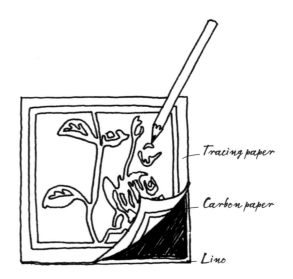

Tracing paper

Carbon paper

Lino

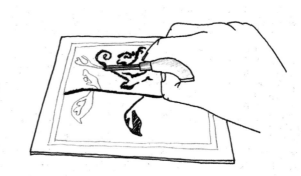

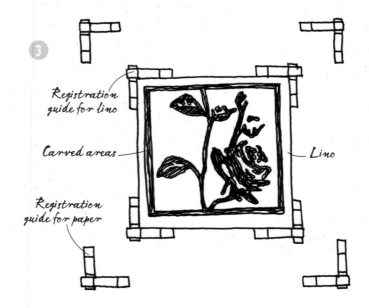

Registration guide for lino

Carved areas

Lino

Registration guide for paper

PRINTING

4: Squeeze a small amount of ink onto the palette and roll the brayer through it until it is evenly coated. By putting two or more colours or shades next to each other on the palette, they can be blended with the roller for a graduated effect when printed. Roll a thin layer of ink over the surface of the lino block. If too much ink is applied, it could seep into the cut-away areas and the result will not be crisp.

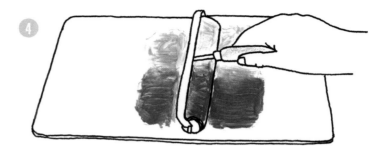

5: With the lino in place within the inner set of guides, carefully place the paper over the lino, lining up the corners with the outer registration guides. Burnish the back of the paper with the baren or the back of a wooden spoon, taking care not to move the paper and smudge the print.

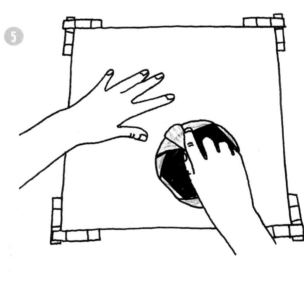

6: Lift the paper at the corner to check how the print looks. If the colour is patchy or pale, touch up the lino with the inked roller, taking care not to move the paper. Burnish again, until you are happy with the result. Carefully remove the printed paper from the lino and allow to dry. Clean the ink from the lino with a damp cloth when the print run is finished. If you wish, you can continue to add more colours using one or other of the techniques described overleaf.

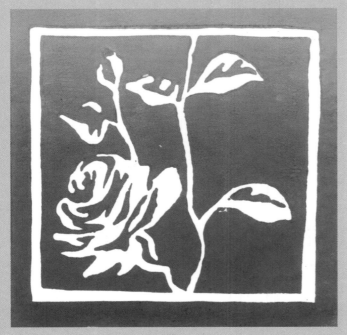

Inverted print

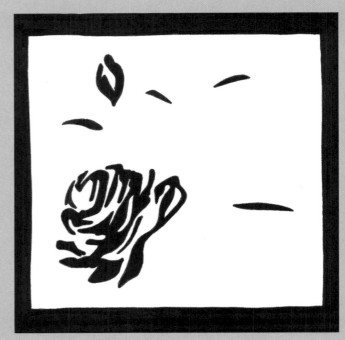

Design for second colour

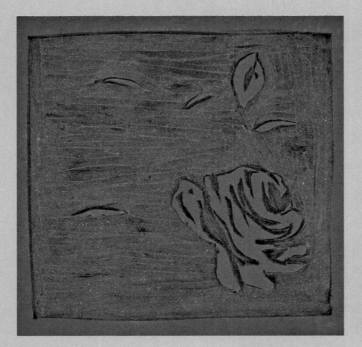

Lino cut for second colour

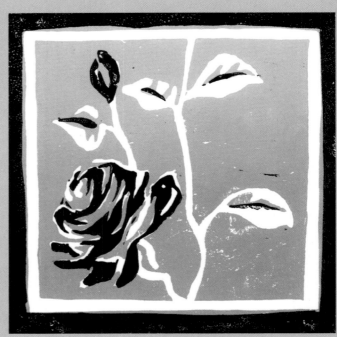

Final print with second colour added

PRINTING SUBSEQUENT COLOURS
CUTTING A SECOND LINO BLOCK

For the second colour plate, print the first design onto a piece of paper. While it is still wet, place the second piece of lino over the paper to provide an inverted print from which you can cut away the areas that you wish to keep in the first colour. Keep the raised parts of the lino for printing the second colour.

In this method, new elements can be introduced to the design by leaving parts of the lino uncut that had been cut away in the last block to stay paper white. Make sure the previous colour is dry before overlaying the next. Print as before, following Steps 4–6, using the registration guides that were put in place for the first colour.

REDUCTION LINO PRINT

For this method, each colour is printed using the same lino block that is cut away after printing for subsequent layers. This results in a limited print run, as you will be left with just the design on the lino block that was used for the final colour. The more colours there are to print means that more will be cut away each time from the original block. Print each layer using the registration guides that marked the position for the first.

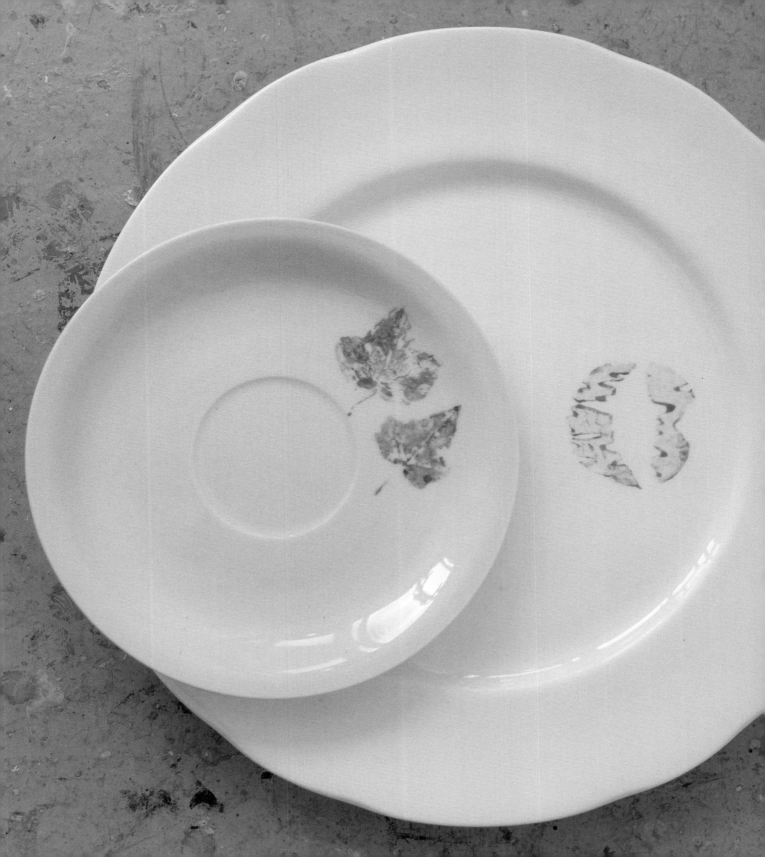

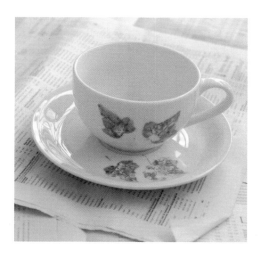

TABLE SETTING

Transform odd pieces of china into a matching set by printing a simple design using objects found around the home and garden. Team up printed crockery with matching printed napkins.

TOOLS AND MATERIALS

- Small potato cut in half
- Kitchen knife
- V-shaped lino-cutting tool
- Ceramic paint
- Ice lolly stick
- Paint palette
- Rubber brayer
- Scrap paper
- Selection of china crockery (such as tea cups, saucers, mugs and plates)
- Small leaves
- Damp cloth

FOR THE NAPKINS

- Napkins, washed and ironed
- Water-based fabric inks or paints, or acrylics mixed with textile medium
- Scrap paper
- Iron
- Dry cloth

TROUBLESHOOTING

- If you are unhappy with the print you have applied to crockery, wipe the paint away before it has dried with a damp cloth.
- Try not to move the potato or leaf when it is applied to the china; it will smudge the print.
- Make sure there is no paint on your fingers; it will mark the china as you handle it.

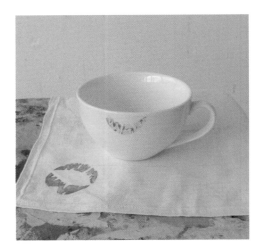

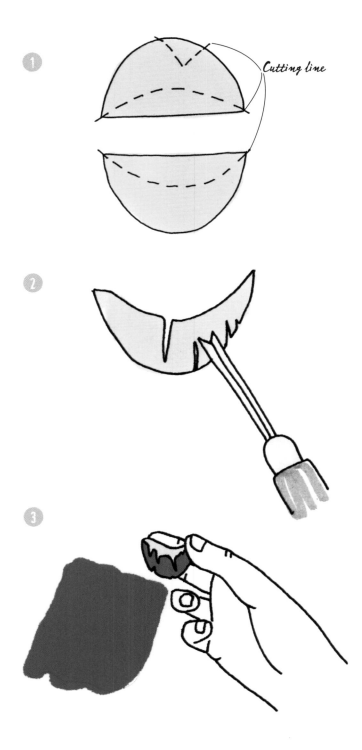

Cutting line

INSTRUCTIONS
CUTTING THE DESIGN

1: Cut the halved potato in half again with a kitchen knife and carefully cut a curve into both pieces to make the top and bottom lips. Using the kitchen knife, carefully cut a 'V' into the top of the top lip to form the Cupid's bow of the lips.

2: Use the lino-cutting tool to make lines in both pieces, cutting away from you to avoid any accidents.

PRINTING THE LIPS

3: Thoroughly stir the ceramic paint with an ice lolly stick, and spoon a small amount onto the paint palette. Use the brayer to roll out a thin, even layer of paint. Coat the bottom lip with the paint by pressing it into the colour or rolling it on with the brayer.

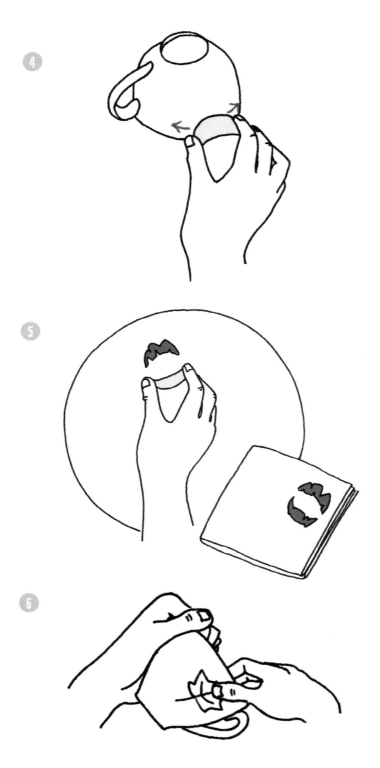

4: Test the print on scrap paper first to make sure it is even and is not overloaded with paint. Turn the cup or mug upside down to print the lipstick mark. With the bottom lip turned upside down, carefully press it onto the cup near the top edge, following the curve of the china. (See Troubleshooting, page 35.) Lift the potato off and leave the paint to dry according to the manufacturer's instructions. Follow the manufacturer's instructions to fix the paint.

5: Print the top and bottom lips together on a plate and napkin to create a matching set. Use fabric inks to print the napkin, testing the potato print on a piece of paper first. Fix the ink when the printed fabric has dried with an iron set at the highest heat suitable for the fabric. Lay a dry cloth over the fabric and iron well for a few minutes on both sides.

PRINTING THE LEAVES

6: Follow Step 3 to prepare the paint and coat the leaf. Press the leaf and stalk into the paint and test the print on a piece of scrap paper first. Place the leaf onto the side of the cup and press along the veins to transfer the lines. (See Troubleshooting, page 35.) When the paint is touch-dry, another colour can be overlaid to produce an interesting effect. Follow the manufacturer's instructions to fix the paint.

HELLO

I LOVE

STAMPS

ERASER STAMPS

Erasers may be fiddly to hold, but they are easy to carve. Vinyl erasers are a particularly good choice because they have a smooth surface that is less prone to crumbling.

A B C D E F G
H I J K L M N
O P Q R S T
U V W X Y Z

TEMPLATE

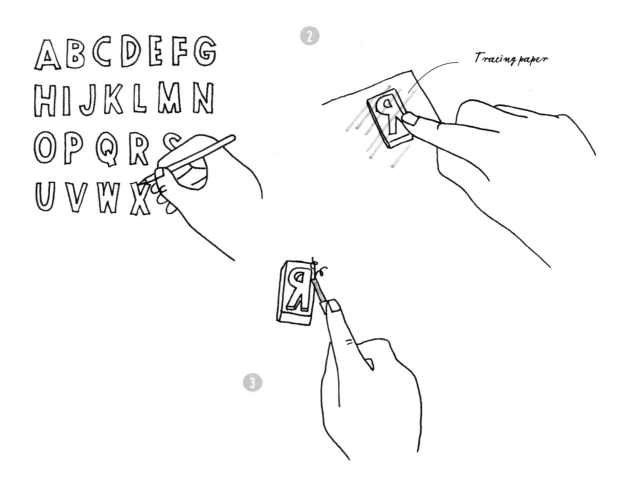

INSTRUCTIONS
TRACING THE LETTERS

1: Enlarge the letters from the template on page 39, as required, and trace onto tracing paper using a soft pencil.

2: With the reverse side facing up, place the tracing paper over an eraser, lining up the chosen letter so that it fits. Rub the top of the tracing paper with a finger or burnish with a bone folder or wooden spoon to transfer the letter on to the surface of the eraser. The letter will appear in reverse.

CUTTING THE DESIGN

3: Place the eraser onto the bench hook and using the lino-cutting tools carefully carve away the areas that are in white on the template. These are the areas that will not be printed. Make sure you keep your fingers behind the work and turn the eraser, rather than the tool, to avoid injury. Use a paintbrush to brush away the residue.

4: When you have cut the letter shape, the printing block is ready to use. Alternatively, carve away the entire eraser around the letter and mount it onto an old wooden toy block using superglue.

PRINTING

5: Cut a piece of felt measuring about 2 x 4in (5 x 10cm). Squeeze a small amount of acrylic paint onto the palette. A little acrylic gel medium can be mixed in to lengthen the drying time and, if necessary, add a little water to thin it down. This enables it to be absorbed into the felt. Use the ice lolly stick to spread the paint over the palette, lay the felt over it and watch the colour seep through.

6: Press the stamp onto the paint-soaked felt, checking that it is evenly covered. Then press it firmly onto a scrap of paper to see how it looks before continuing to print on your chosen surface. (See Troubleshooting, page 39.) Put the finished prints to one side and leave to dry.

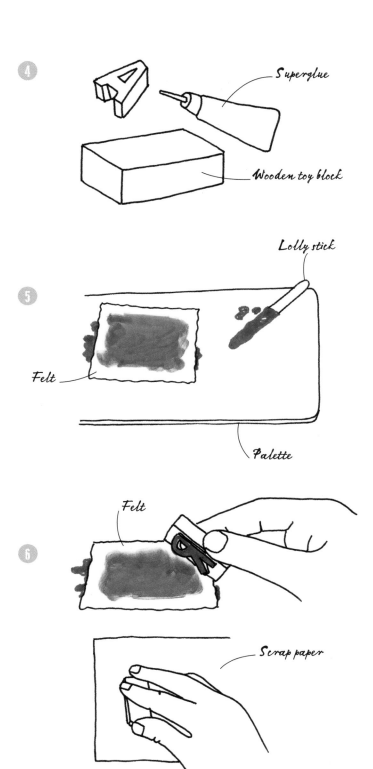

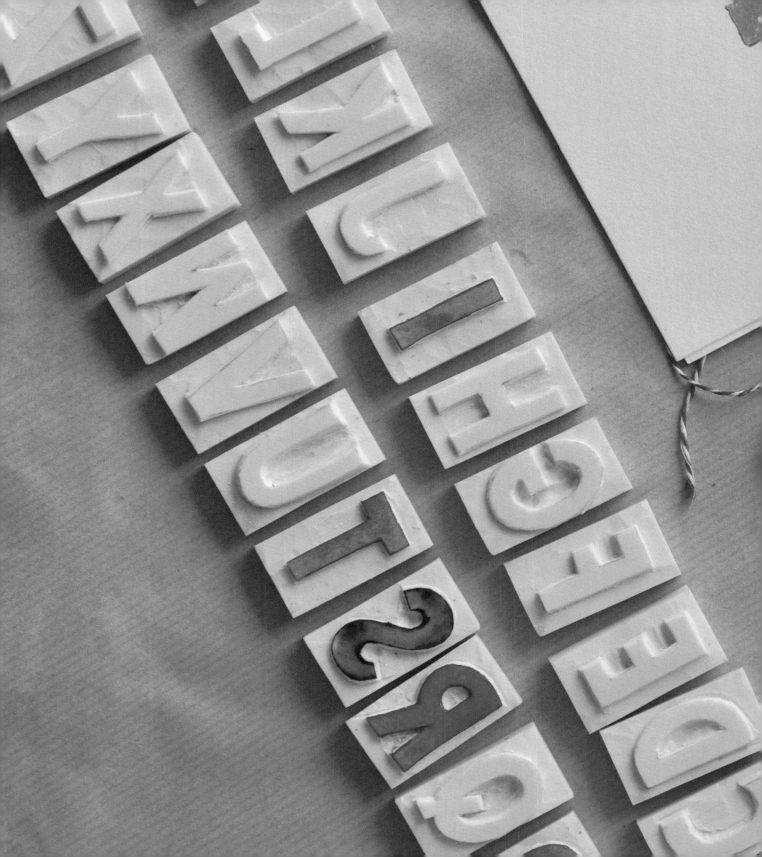

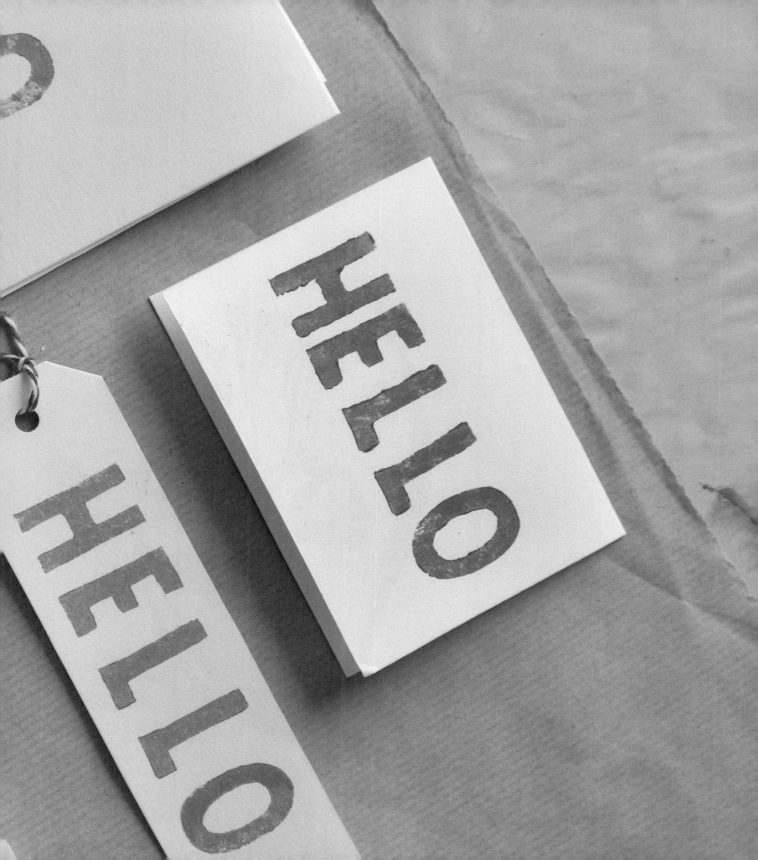

WALLPAPER

Hand-printed wallpaper is far removed from mass-produced designs. The idiosyncrasies that appear in the print only add to the unique quality, making it even more special. Lino has been used to create this striking floral design.

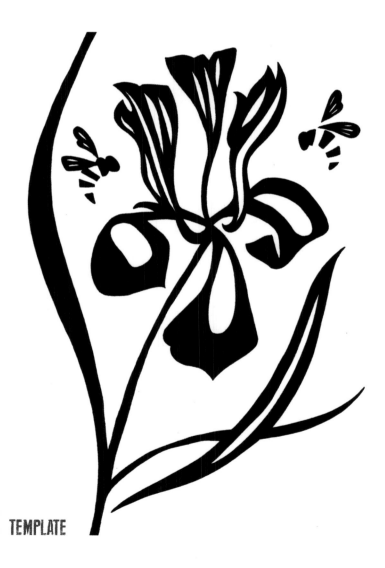

TEMPLATE

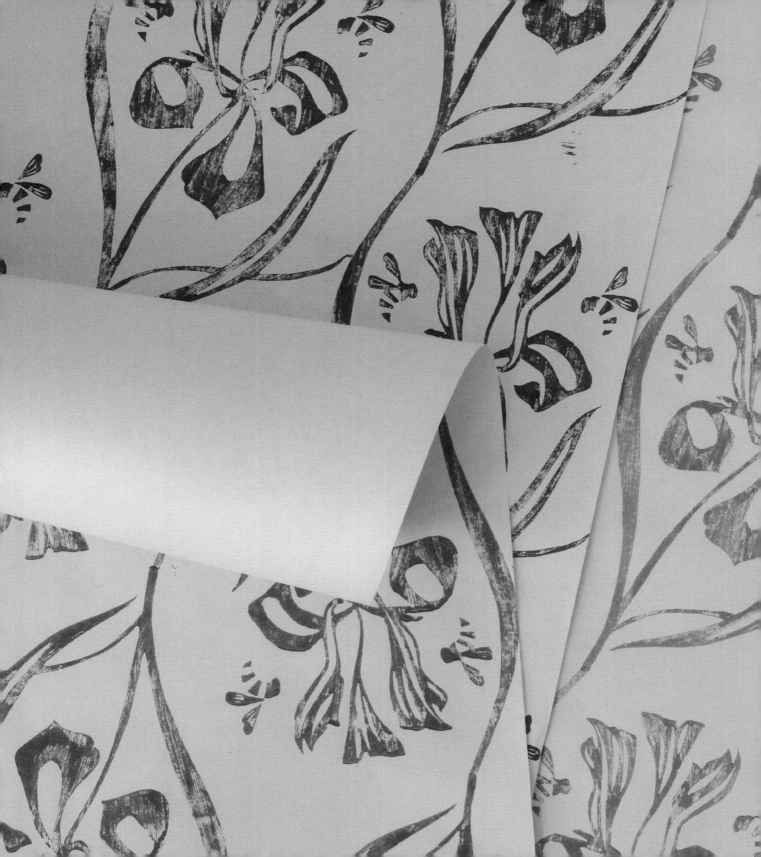

INSTRUCTIONS

PREPARING THE PATTERN

1: Before you begin, divide the width of the lining paper by the amount of pattern repeats you will print across it. Using the utility knife cut the sides of the lino to size. This wallpaper project is printed in three columns to each length of lining paper. Enlarge the template to fit the lino, or use your own artwork.

2: When printing wallpaper, it is important to work out how the artwork will repeat and, if the pattern should meet at each side, top and bottom of the design. This can be done by cutting a copy of your artwork into quarters and laying them out in different sequences to see if the lines continue smoothly. If they don't, you can correct them.

3: The iris template on page 44 is designed to meet at the top and bottom and is printed as a half-drop. This means that rather than the pattern being repeated in the same position next to the first, it starts halfway up the flower. Copy the enlarged template onto tracing paper. Place the traced artwork face down on the lino and slip carbon paper, carbon-side down, between the tracing paper and the lino. Draw over the traced outline with a pencil. The artwork will appear in reverse on the lino. Alternatively, the design can be drawn directly onto the surface of the lino using a felt-tip pen or a pencil.

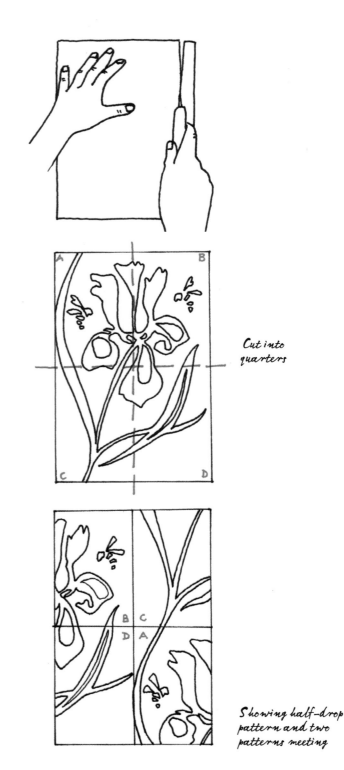

Cut into quarters

Showing half-drop pattern and two patterns meeting

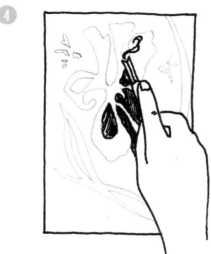

CUTTING THE DESIGN

4: Using the lino-cutting tools and the bench hook, cut away the areas that are in white on the template. The areas of the design in black on the template and that have been left uncut on the lino will be printed. As you cut the surface away, turn the lino block instead of the tool and keep your fingers behind the work to avoid injury. Use a paintbrush to remove the lino residue.

5: To strengthen the lino, glue it to a cork floor tile or fibreboard with the spray mount. Mark the lines that will meet on the back of the block, as this will help register the design when printing. Draw a straight, horizontal line across the centre of the back of the block to mark the halfway point. This will be used to line the first of the half-drop pattern. Finally, draw an arrow on the back to show which way up the block should go.

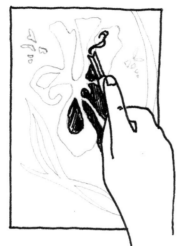

Line up with iris stalk

This way up

Centre of design to line up half-drop

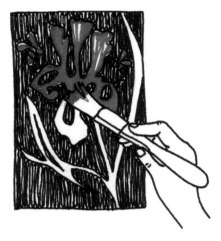

PRINTING

6: Cover the work surface with newspaper. Paint the emulsion onto the carved lino and do a proof on a scrap of paper to check how the image prints (see Troubleshooting, page 44). Roll the brayer over the back of the block so that it makes contact evenly with the paper. If necessary, the lino can be reworked with the cutting tools before printing onto the lining paper.

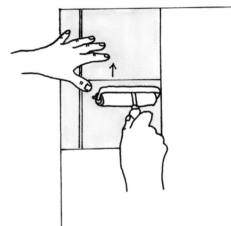

7: Lay out the lining paper. Lengths of the paper can be cut prior to printing, but make sure the edge is straight so the block can be lined up accurately. Paint the emulsion on the block and, with the painted side face down, align the top and side of the lino block to the top left-hand corner of the lining paper. Use the brayer to roll over the back of the block and then carefully lift the lino from the paper.

8: Re-apply the emulsion to the lino and, working below the first print, line up the relevant marks made on the back of the block with the printed pattern. Print as before. Repeat the process to print two pattern repeats down the right-hand side of the lining paper.

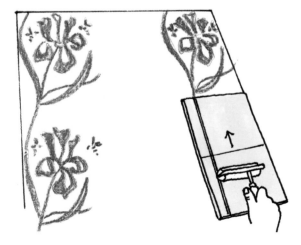

9: For the half-drop pattern, start at the centre of the top edge of the lining paper. Align the horizontal line drawn across the middle of the back of the block with the edge of the paper and lay the painted block face down between the two columns of pattern.

10: Roll the brayer over the back of the block, then lift it from the paper and paint a new coat of emulsion on the lino. Make another print beneath the first, taking care to keep the side edges of the block parallel to the edges of the lining paper and matching the relevant markings made on the back of the block with the printed pattern. Continue this way, recharging the block with paint and printing down and across the paper to the end.

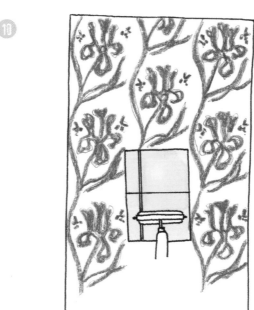

11: When you have finished, leave the printed wallpaper to dry and clean the paintbrush with water. Use a damp sponge to clean the block and blot with newspaper.

Scrunched up newspaper

SCREEN PRINTING

Screen printing is a method of making stencils in which colour is applied to a surface by forcing it through a fine mesh fabric with a squeegee. Originally, silk was used to cover the frame of the screen but it was later replaced by polyester mesh, which is far more durable.

In the 1850s, the Japanese developed intricate stencils for kimonos, which they screen printed onto fabric. During the first half of the twentieth century, screen printing was used widely for commercial advertising, packaging and textiles. As technology developed, photographic stencils were used in screen printing, which produced more refined images. In the 1960s, artists such as Victor Vasarely (1906–97), Bridget Riley (b. 1931), Andy Warhol (1928–87) and Roy Lichtenstein (1923–97) used screen printing. As well as creating multiple pieces, the bright, solid colours that were produced by this process were ideal for the work of Op Artists and Pop Artists alike.

Wood, card, plastic, leather, glass, textiles and almost any surface can be screen printed, making this process a very exciting technique.

TOOLS AND MATERIALS

SCREEN

The screen is a wooden or aluminium frame with a fine mesh fabric stretched over it. Ink is forced through the fabric onto the surface producing an even coat of colour. The size of the mesh count varies according to the printing requirements. It is measured by how many threads there are to $3/8$in (1cm). For example, 32T is a course weave, suitable for printing fabrics, whereas 120T is a fine weave, suitable for detailed prints on paper.

The fabric comes in white and yellow. Yellow is used for photosensitive printing, allowing for direct light contact. On a white mesh, the UV light would bounce off the fabric and hit unwanted areas.

HOME-MADE SCREEN

It is simple to make a screen from scratch (see page 57). You will need a wooden picture frame with a flat surface. Screen-printing mesh is available to buy by the yard or metre. For a cheaper alternative, polyester organza fabric can be used (not nylon, as it stretches, and the fabric needs to be taut over the frame). Any clips, staples and hooks will need to be taken out using pliers and a screw driver. The frame may need to be sanded down with sandpaper to remove any splinters that can tear the fabric or varnish that will prevent the glue from adhering. The mesh is attached using a heavy-duty staple gun (a stapler will not be strong enough to force the staples through the wood). Wood adhesive is used to glue the mesh to the front of the frame. Use waterproof adhesive as the screen will be getting wet during printing and when cleaning up.

SCREEN BASE-BOARD

Attaching your screen to a base will make printing much easier. The base becomes the working surface and enables you to lift the screen and then lower it again in exactly the same position. This is especially helpful when you want to create a number of prints or introduce more than one colour to your design. To make a base for the screen, screw a baton into one end of a sheet of hardboard or plywood and hinge the frame to the baton using loose pin butt hinges. This enables you to separate the screen from the base by removing the pin that holds the two halves of the hinge together. The screen can be easily reattached by lining up the two halves of the hinge and inserting the pin to join them. Add a kick-leg by screwing a thin piece of wood in to the side of the frame so it swings freely to hold the screen up when registering the prints.

SQUEEGEE

A squeegee is a plastic or rubber blade encased in a wooden handle that is pulled across a screen to force the ink through the mesh. A soft blade is suitable for fabric printing and is orange in colour. The standard, medium blade is green and the hard blade, used for detailed prints, is blue. The squeegee should be longer than the printed area you are working on.

INK

I use acrylic ink for screen printing. Colours can be mixed and thinned with a little water. Fabric screen-printing ink is available for printing on natural fibres or a textile medium can be mixed to acrylic printing inks. These need to be heat fixed with an iron. I have also used emulsion paint for screen printing, but be very careful not to let it dry into the screen.

SCREEN-PRINTING MEDIUM

Acrylic screen-printing medium is used to slow down the drying time of the ink, reducing the risk of blocking the mesh on the screen and making it easier to clean after use. When it is mixed into the ink, the density of the colour is not affected. The medium can be thinned with water.

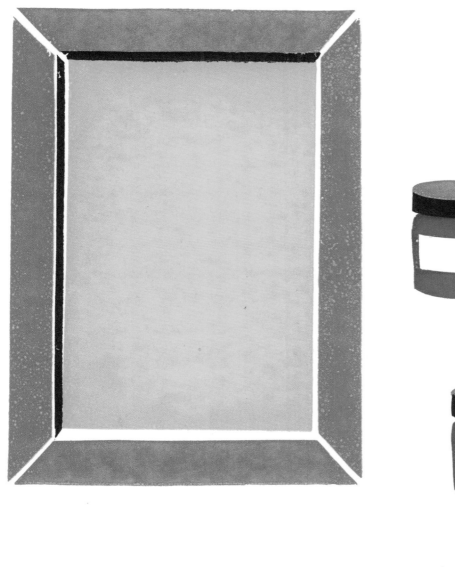

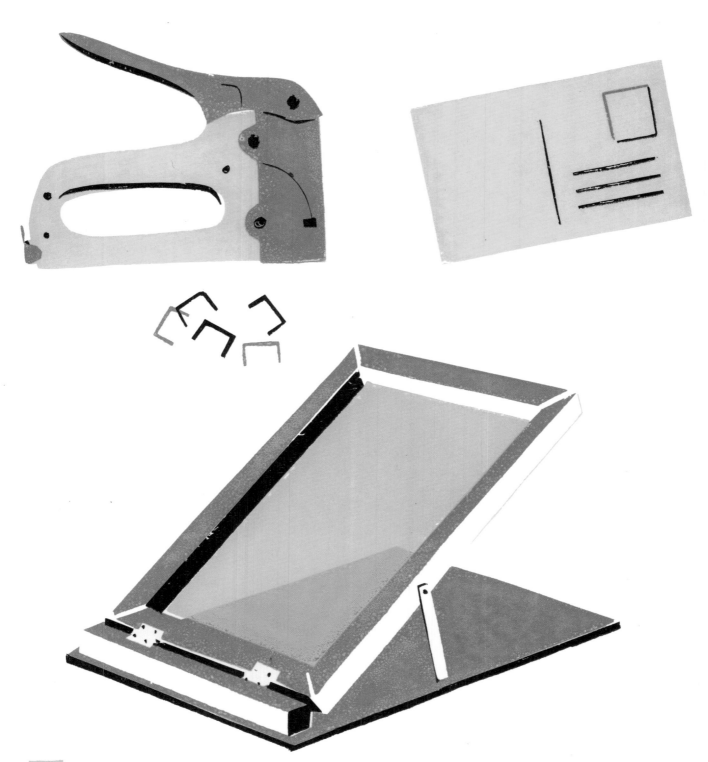

SCREEN FILLER

Screen filler is used to block areas of the screen that are not to be printed. It is painted on and left to dry. It works in a similar way to the stencil, as the ink is forced through the areas that have not been blocked out with screen filler. It is more durable than the newsprint stencil. The screen should be held up to a light when it is dry to check for any pinholes in the screen filler which will need touching up before printing. After use, remove the screen filler with a screen filler remover (see below).

SCREEN-CLEANING FLUID

It is important to clean the screen thoroughly after use. When printing with newsprint stencils, the residue ink can be removed simply using water and a sponge or soft brush. However, if the ink is allowed to dry, it will clog the screen and affect future prints. Screen cleaning fluid can be used to thoroughly clean the mesh and remove residual ink and screen filler. There is also a screen-filler remover available that is produced especially to clean up the screen filler. It is applied on both sides of the screen with a paintbrush and scrubbed with a nylon bristle brush and then rinsed off. It is then reapplied to both sides and left to stand horizontally before rinsing off again while scrubbing the screen with a brush. Always check the manufacturer's instructions because they can vary.

PAPER

I prefer screen printing on heavy paper with a smooth surface, but it is fun to experiment with different weights and textures. Attach it to the screen base with a few strips of masking tape to keep it from sticking to the ink on the screen.

NEWSPRINT

Stencils are cut from newsprint. It is very lightweight and quite transparent. When the ink is pulled across the screen, the newsprint sticks to the mesh and the colour goes through the areas that have been cut, producing the design on the paper. However, each stencil can only be used a limited number of times as the newsprint gets wetter with every run of ink that goes over it, causing it to tear and cockle.

CARD

Oblong strips cut from greeting cards or postcards are ideal for registering screen prints. It is important to use the original, straight edge of the card to line up against the edges of the paper to provide an accurate marker.

OTHER USEFUL ITEMS
HEAVY-DUTY STAPLE GUN

This is a great tool for fixing your screen-printing mesh and canvas to frames. A desktop stapler is not good for this job though.

OLD LIBRARY OR BANK CARD

These are ideal for scraping up the excess ink from the screen when you have finished printing.

LIDDED JAR

The excess ink that has been removed from the screen can be kept for future use in a clean, lidded jar or pot. If the container is not see-through, mark the lid with a little of the ink it holds so you can easily identify the colour.

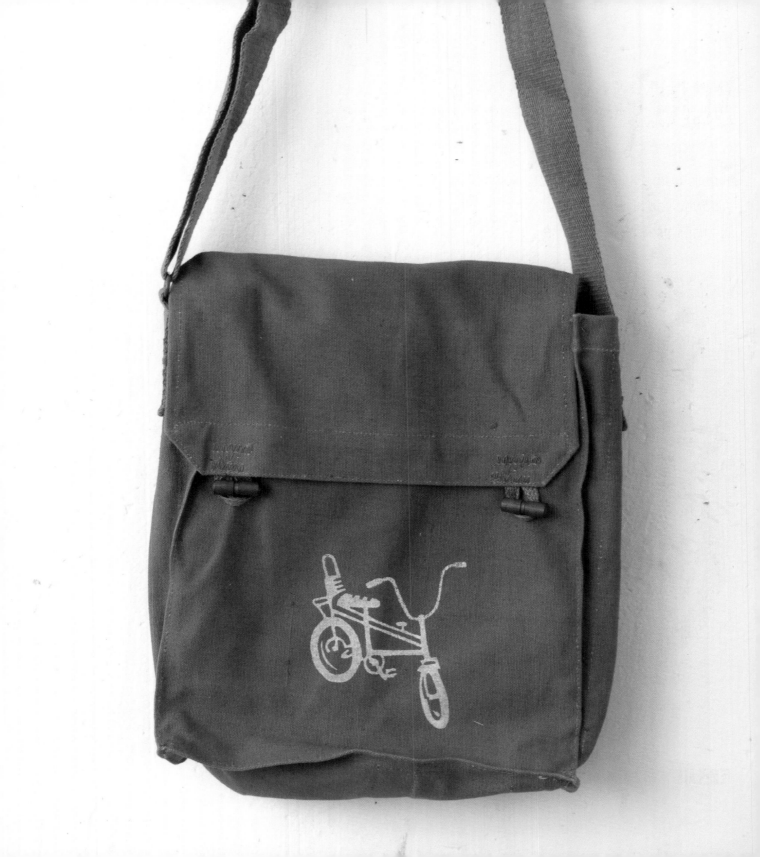

SCREEN AND BAG

A silk screen frame can be made on a budget using a wooden picture frame. By painting a design onto the mesh with screen filler you can add a personal touch to screen-printed items such as this canvas messenger bag.

- Simple wooden picture frame with a flat surface
- Pliers and screwdriver
- Sandpaper
- Screen-printing mesh or polyester organza fabric to cover one side of the whole frame with an extra 2in (5cm) all around
- Heavy-duty staple gun and staples
- Waterproof wood adhesive
- Paintbrush
- Scissors
- Masking tape

FOR THE PRINTED BAG
- Soft pencil
- Screen filler
- Canvas bag
- Masking tape
- Fine paintbrush and larger paintbrush
- Packing tape
- Water-based fabric inks or paints, or acrylics mixed with textile medium
- Spoon
- Squeegee to fit inside the frame
- Scrap paper or fabric
- Dry cloth
- Iron
- Old library or bank card
- Sponge
- Screen-filler remover (optional)

TROUBLESHOOTING
- If there is spotting in non-printed areas, check there are no pinholes or gaps in the blocked-out mesh by holding it up to the light. Check each time you wash the screen.

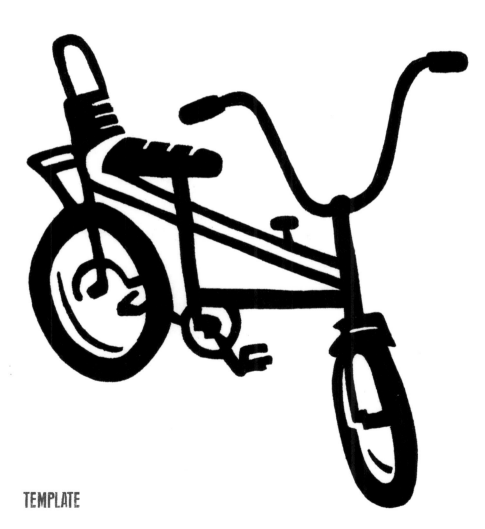

TEMPLATE

INSTRUCTIONS
MAKING THE SCREEN

1: Carefully remove the glass and the board at the back of the picture frame. Use pliers to gently pull out any metal clips or staples that were holding in the glass and board, and a screwdriver to unscrew picture-hanging rings and plates. Make sure the frame is smooth, sanding down any varnish and splintered wood if necessary.

2: Staple the mesh down along the edge of one side of the frame and then, pulling the fabric tight, staple it along the opposite edge. Pull the fabric taut over the frame and staple it down along each remaining edge so the mesh is attached to all four sides of the frame.

3: Paint the front of the fabric-covered frame with waterproof wood adhesive, working it slightly over the inside edge to prevent the printing ink from seeping through. Put the frame to one side to dry.

Sandpaper

4: When the adhesive has completely dried on the front of the frame, trim the excess mesh with scissors and attach masking tape around the edges and over the staples.

PREPARING THE SCREEN

5: Enlarge the template on page 57 to the required size to fit the bag. Lay the screen over the template with the front, recessed side facing up and use a soft pencil to trace the design onto the mesh.

6: Turn the screen over and place it on a light-coloured surface so that the lines you have made show up clearly. Stir the screen filler liquid well then paint it over the area you do not wish to print. These are in white on the template. Use the fine brush to go around the smaller, more complicated areas and the larger brush to fill the space between the design and the edge of the frame. Remember that the screen filler is painted onto the areas that will not be printed; it is a negative of the design that you will produce. Allow to dry overnight. When the screen is dry, hold it up to the light to check for missed patches and pinpricks, which should be painted out with more screen filler. Leave the screen to dry completely before printing.

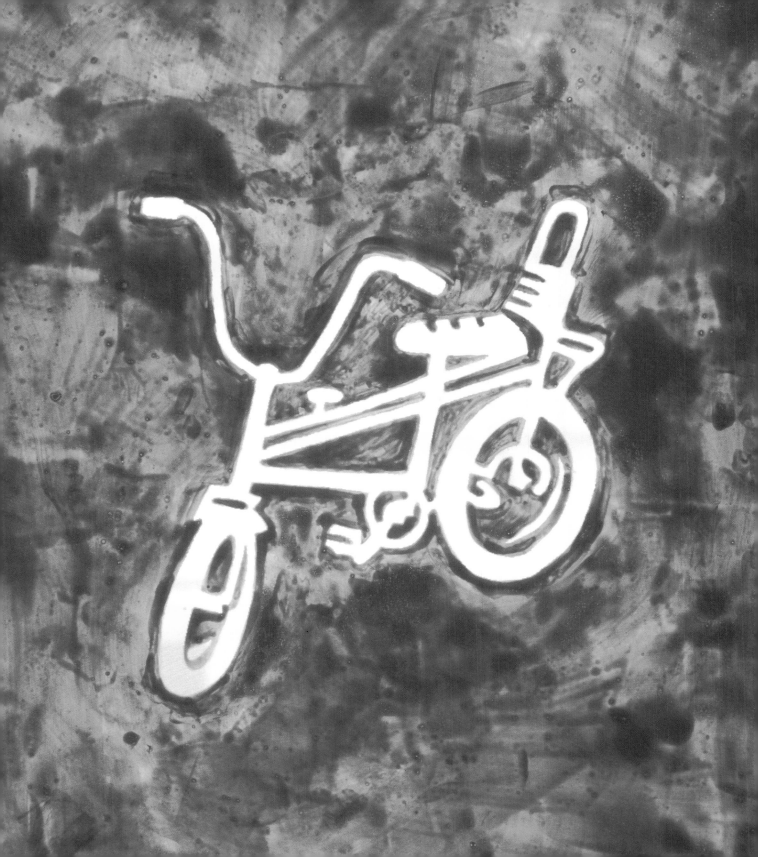

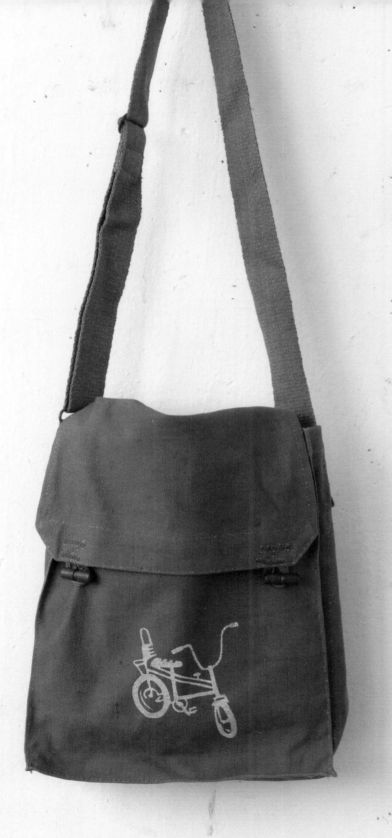

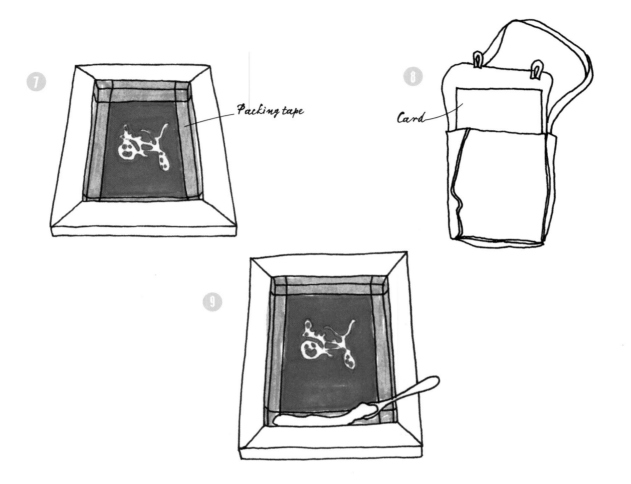

Packing tape

Card

7: Apply strips of packing tape around the inside edges of the screen and a little way up the frame. This is to stop the ink bleeding under the frame when printing. There should be a margin of at least 1in (2.5cm) between the taped edge and the design.

PREPARING THE BAG

8: Depending on the style, you may want to print onto the flap or on the main part of the front of the bag. If you are printing onto the bag flap, open it up and lay it on a flat surface, sticking the edges down with masking tape to stop it slipping. If the print is going on the main part of the bag, slip some thick paper or card inside to prevent the colour seeping through to the back. Remove any buttons that might get in the way of the screen and put them in a safe place so they can be stitched back on after the ink has dried.

PRINTING

9: If you are using a textile medium with your printing inks, prepare the colour following the manufacturer's instructions. Spoon a line of ink across the end of the screen that is nearest to you and use the squeegee to push the ink across the mesh to the back of the screen. The screen is now coated with ink, ready for printing.

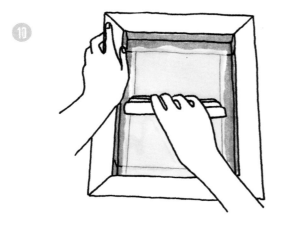

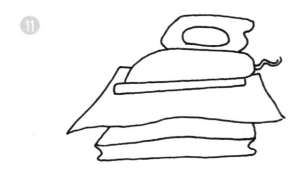

10: Print a proof on fabric or paper first. Place the screen onto the surface to be printed and, with one hand holding firmly onto the frame and the squeegee in the other hand at a 45-degree angle to the mesh, pull the ink back towards you. The colour has been pushed through the mesh onto the fabric. Lift the screen and push the ink back across the mesh ready for the next print. If the ink bleeds under the outlines of the open areas of the screen, it is too runny. Clean the screen with water and leave to dry before printing, using ink that is of a creamy consistency. When you are happy with the proof (see Troubleshooting, page 57), place the screen onto the bag and repeat the process. Move the printed bag to one side to dry.

11: When the ink is dry, fix the print by placing a dry cloth over it and ironing well for a few minutes at the highest heat suitable for the fabric.

CLEANING UP

12: The screen should be cleaned before the ink dries onto the mesh. With an old library card or bank card, remove any excess ink from the screen. This can then be saved in a clean, lidded jam jar for future use. Use water and a sponge to wash the residue ink from the screen and allow to dry. If you do not wish to keep the design and want to use the screen for a new artwork, the screen filler will need to be removed using a screen-filler remover.

TOOLS AND MATERIALS

- Tracing paper
- Pencil
- Newsprint
- Carbon paper
- Craft knife and cutting mat
- Screen and hinged base
- 4 coins
- Scissors
- Packing tape
- Acetate
- Card
- Masking tape
- Acrylic screen-printing ink
- Scrap paper and paper to print on
- Squeegee
- Spoon
- Sponge
- Glue stick (optional for envelopes)

TROUBLESHOOTING

- If you accidentally cut into too much of the stencil or cut away a piece, a thin slither of masking tape can be used to cover the section or stick the piece back without having to start all over again.

- If the acrylic is too fluid it could bleed beneath the stencil. If this happens, the lines on the print won't be sharp and the colour will be washed out. The stencil could become too wet and a new one may need to be cut.

- If the ink is too thick it will clog up the mesh, dry out and damage the screen. If it is very thick, add a little water. The inks should be of a creamy consistency. You can use a screen-printing medium to slow down the drying of the ink and reduce the risk of it blocking the screen.

TEMPLATES

STENCIL SCREEN PRINT

Screen printing with stencils is an exciting and inexpensive way of producing multiple prints. This technique is perfect for creating unique stationery.

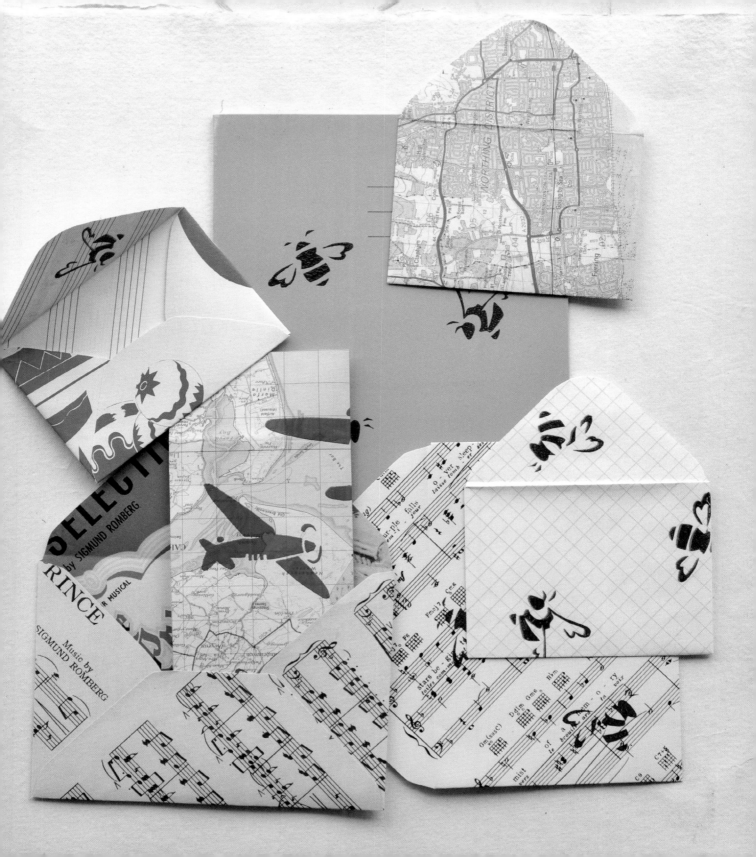

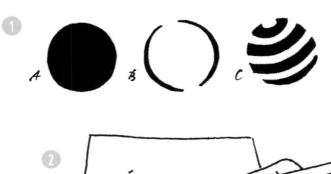

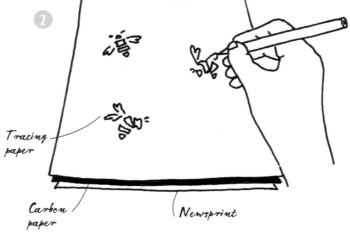

INSTRUCTIONS

CUTTING THE STENCIL

1: When creating artwork for a stencil, consider the lines and how it will need to be cut. The same shape can be cut in various ways to give different results. Cutting around the whole outline will produce a solid shape with no detail when printed **(A)**. Narrow lines can be cut away to reveal the form without removing the whole area. This effect is achieved by leaving small sections uncut to hold the pieces together. Or the inner section can be taken out and positioned separately inside the cut lines when ready to print **(B)**. Another way to add interest and detail is to cut a design within the image to indicate the shape **(C)**.

2: Enlarge or reduce one of the templates on page 64 to the desired size and trace the design onto the tracing paper or use your own artwork. Cut the newsprint to the size of the printing paper and transfer the design by slipping carbon paper, carbon-side down, between the newsprint and the artwork and tracing over the outlines with a pencil. Alternatively, flip the tracing paper and draw over the pencil lines showing through on the reverse side to transfer the image to the newsprint.

3: With a craft knife and cutting mat, carefully cut away the sections from the newsprint that are shaded in black on the template (see Troubleshooting, page 64). These are the areas that will be printed. Make sure the knife is sharp to prevent the paper tearing and to ensure the lines are smooth.

PREPARING THE SCREEN

4: Attach the screen to the hinged base (see page 52) and stick coins to each corner of the underside of the screen with a strip of masking tape. This will raise it slightly and enable it to bounce back from the paper after the ink has been pulled across the screen, preventing it from sticking to the print.

5: To stop excess colour seeping between the frame and the mesh onto the print, apply packing tape along the inside edges of the mesh and a little way up the frame of the screen.

6: Position the paper to be printed by laying it onto the centre of the base then lowering the screen. The edges of the design should not be closer than 1in (2.5cm) to the frame. If there is an exposed gap between the taped edge and the paper it can be filled with more packing tape. Acetate can be taped over any larger areas. This can be washed after printing and used again.

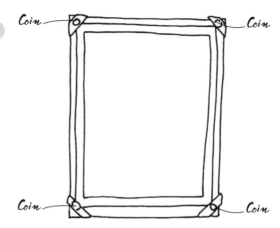

Coin Coin

Coin Coin

Packing tape

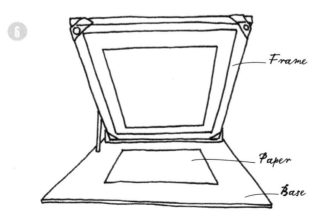

Frame

Paper

Base

REGISTRATION

7: When you are happy with the position of the paper, carefully lift the screen so that the edges can be registered. Cut three rectangles from the card and, using masking tape, stick two of the lengths against the long edge and the third at the shorter edge. To ensure the registration is accurate, place the actual edges of the card, rather than the edges you have cut, right up against the edges of the paper.

PRINTING

8: A proof should be printed first to check you are happy with the colour and the quality. Use scrap paper for this. Cut the paper to the same size as the printing paper and secure it to the base with a couple of strips of masking tape. This will prevent it sticking to the screen when the ink has been applied. Place the stencil on the paper and carefully lower the screen.

9: Spoon a line of ink across the end of the screen nearest to you. (See Troubleshooting, page 64, for guidance on the consistency of the ink.) Lift the screen a little and use the squeegee to push the ink across the mesh to the back of the screen. This will coat the screen and make it ready for printing. Lower the screen.

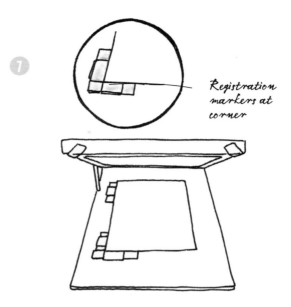

Registration markers at corner

Lay stencil here

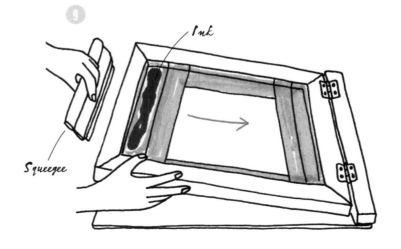

Ink

Squeegee

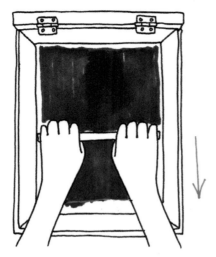

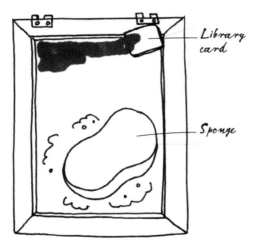

Library card

Sponge

10: With the squeegee at a 45-degree angle to the mesh, use both hands to pull the ink back towards you, maintaining an even pressure. The colour is pushed through the mesh and the open areas of the stencil onto the paper beneath. Raise the screen and push the line of ink to the back of the screen again, ready for the next print. The ink will stick the stencil to the screen. Use masking tape to stick the excess newspaper down. Move the printed paper to one side and leave it to dry. Lay the next piece of paper to be printed onto the base, lining it up against the registration markers and tape it down as before to secure it to the base.

CLEANING UP

11: The screen should be washed immediately after the final print to prevent any ink drying on the mesh. Use an old library card to remove excess ink (this can be saved in a clean lidded jar for future printing projects). Remove the stencil and masking tape and detach the screen from the hinged base. Wash the screen thoroughly using water and a sponge. Leave to dry.

STATIONERY

12: As well as plain, graph and lined paper, exercise books, old maps, music sheets and manuscripts can make interesting backgrounds for a stencilled design and can be turned into a unique stationery set. Use an envelope as a template to make your own by carefully pulling apart the glued edges and cutting your printed paper to the same shape and size. Fold and glue along the same edges as the original to form the finished envelope.

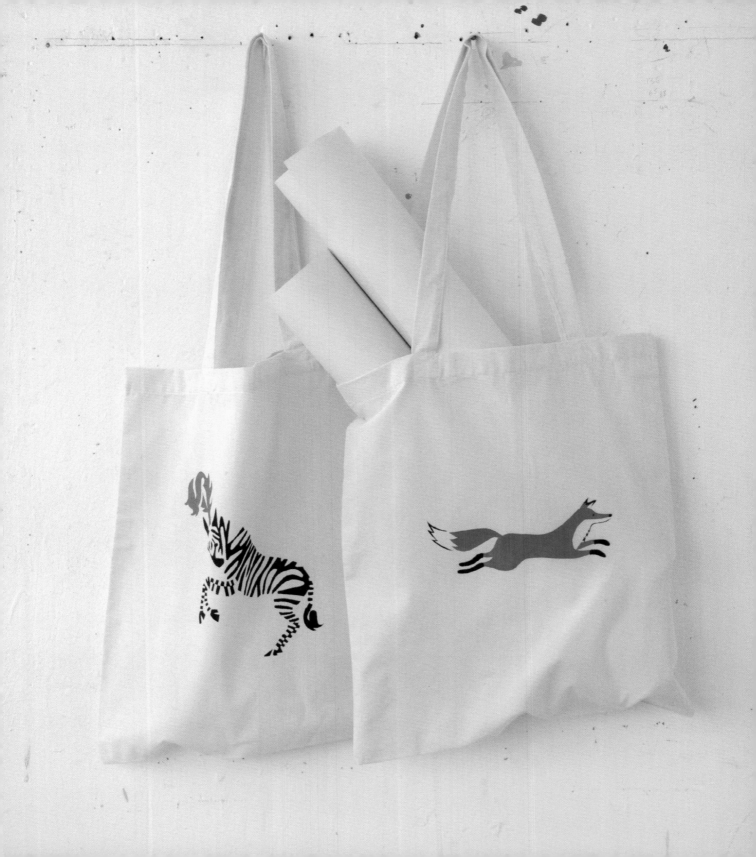

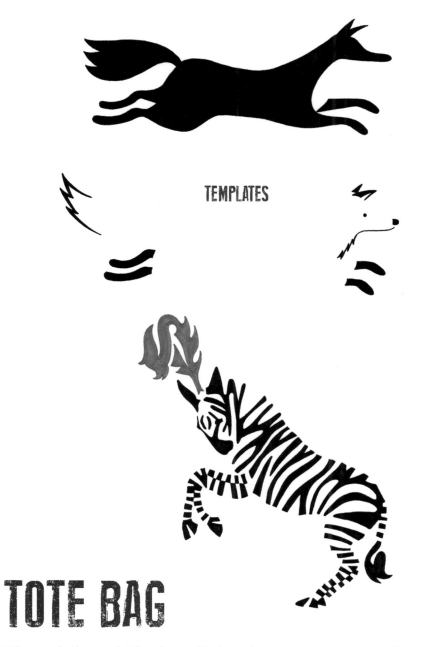

TEMPLATES

- Tracing paper
- Pencil
- Carbon paper
- Newsprint
- Screen and hinged base
- 4 coins
- Masking tape
- Scissors
- Craft knife
- Cutting mat
- Card, same size as bag
- Plain cotton fabric bag
- Packing tape
- Water-based fabric inks or paints, or acrylics mixed with textile medium
- Spoon
- Squeegee
- Sponge
- Acetate
- Dry cloth
- Iron

TROUBLESHOOTING

- Check the ink is not too thick (it should be of a creamy consistency) and do not allow it to dry on the screen since it can clog the mesh. If it is too thick, add a little water. You can use a screen-printing medium to slow down the drying of the ink and reduce the risk of it blocking the screen.

- Remember to move the acetate to one side before printing onto the bag.

- If the ink appears faint on the bag, try repeating the process to print a second layer over the first.

TOTE BAG

When printing a design in multiple colourways, as seen on these fun tote bags, a sheet of acetate is used to help position the subsequent stencils after the first shade is printed. You'll find this is far more accurate than aligning each colour by eye.

INSTRUCTIONS

PREPARING THE DESIGN

1: Enlarge the templates on page 73 to the required size or use your own artwork. Cut the stencil for each colour, following Steps 2–3 of Stencil Screen Print (see page 64). Then prepare the screen following Steps 4–5 on page 67. Slip a piece of card inside the bag to prevent the ink from seeping through to the other side. Place the bag on the base of the screen and apply a couple of strips of masking tape to stop the bag moving during printing. Lay the stencil in position on the front of the bag. Lower the screen and apply packing tape around any areas exposed between the stencil and the taped edge of the frame.

PRINTING THE FIRST COLOUR

2: The lightest colour is usually printed first – this is the case for the fox template. But for the zebra, the body should be the first template as it is easier to position, and its feather headdress does not overlap the rest of the print. Prepare the colour, following the manufacturer's instructions if using a textile medium. (See Troubleshooting, page 73, for guidance on ink consistency.) Spoon a line of ink across the end of the screen that is nearest to you. To coat the screen for printing, lift it up a little and push the ink lightly across the mesh to the back of the frame. Lower the screen. Use both hands to pull the ink back towards you with the squeegee at a 45-degree angle to the mesh, making sure you maintain an even pressure. Remove the bag and set to one side to dry, leaving the card inside.

3: Clean the screen thoroughly (see Step 11, page 69), removing any excess ink first. This can be kept in a lidded jar for future use. Discard the packing tape and stencil and then wash the mesh with warm water and a sponge. Allow to dry before continuing with the next colour.

REGISTRATION

4: Apply packing tape around the edges of the screen. Lay the bag, with the card still inside, on the base of the screen and cut the acetate a little shorter than the length of the bag and wider than the width. Use a long strip of packing tape to stick down one side to the surface under the screen. This will work as a hinge, which can be turned back when you are ready to print the second colour. Use a couple of short lengths of masking tape to stick the other side down to keep it in place. The exposed end of the bag will allow it to be lined up accurately without having to move the acetate. Lay the second stencil over the acetate, aligning it by eye with the print on the bag. Lower the screen and apply more tape if necessary to any exposed areas between the stencil and the taped edges of the frame to prevent any ink going through to the bag to where you do not want it.

5: Spoon a line of the second colour onto the screen, across the end nearest to you. Lift the screen and push the ink to the back of the frame to coat the screen for the next print. Lower the screen onto the acetate and use the squeegee to pull the ink back towards you as for the first colour in Step 2. Lift the screen and push the ink back to the far end of the screen and rest the squeegee at the back of the screen with the ink.

PRINTING THE SECOND COLOUR

6: The second colour will now be printed onto the acetate. The bag can be moved to align the first image printed on it with the second colour image that is printed on the acetate. Use a couple of strips of masking tape to secure the bag to the base and tape down the corners of the stencil to the screen to prevent it from moving. Lift the masking-taped edge of the acetate and turn it on its packing-taped hinge so it is out of the way (see Troubleshooting, page 73). Carefully lower the screen. Using both hands on the squeegee, pull the ink towards you as before to print the second colour onto the bag. Lift the screen and move the bag to one side to dry, leaving the card inside. Repeat Step 3 to clean the screen. When the bag has dried, fix the print by laying a clean dry cloth over it and ironing for a few minutes on both sides, using the highest setting suitable for the fabric.

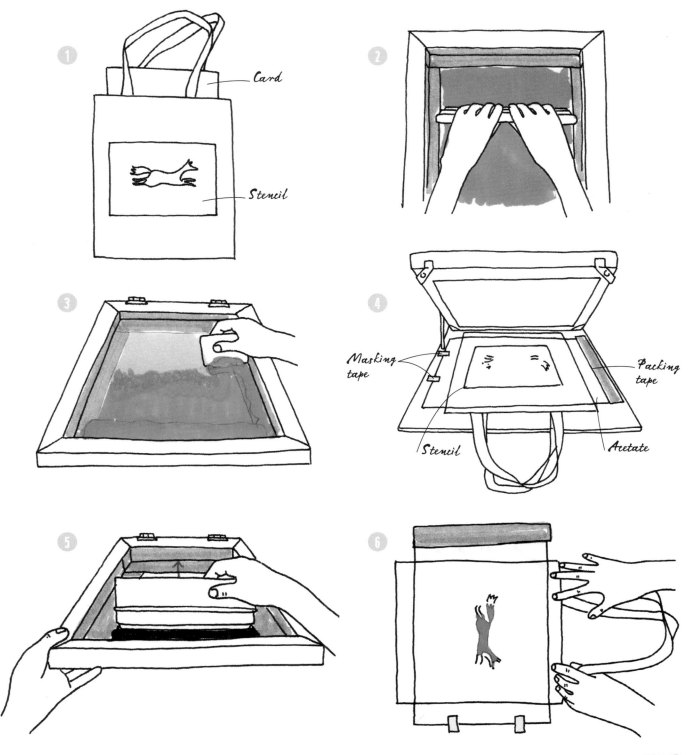

1. Card
 Stencil

2.

3.

4. Masking tape
 Packing tape
 Stencil
 Acetate

5.

6.

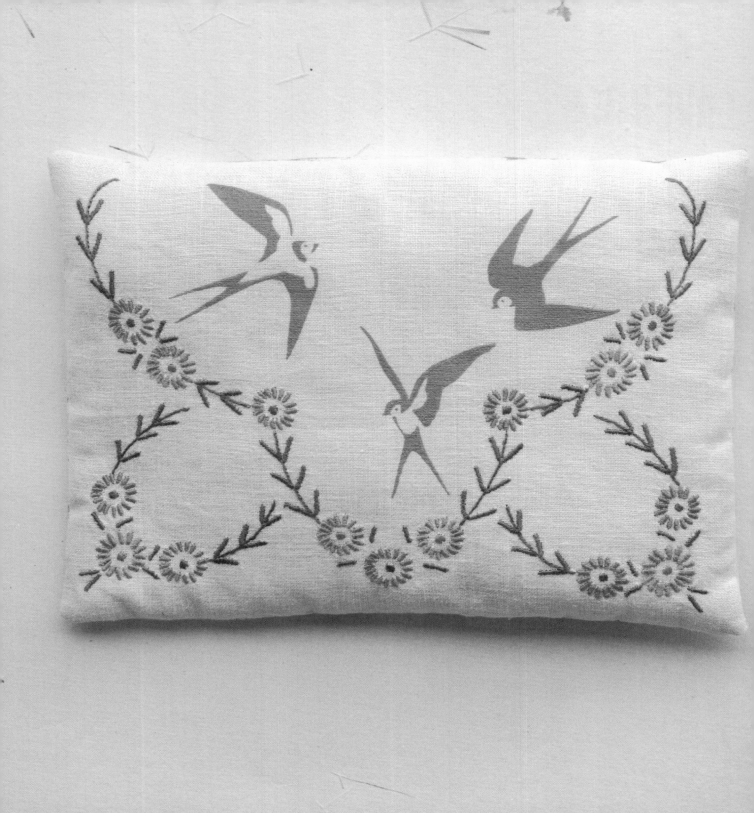

LAVENDER CUSHION

This swallow design is printed on pretty embroidered linen, such as a set of napkins or a larger tray cloth, which can then be made into lavender cushions. They make a lovely way to scent drawers and, if added to a bed, may aid sleep.

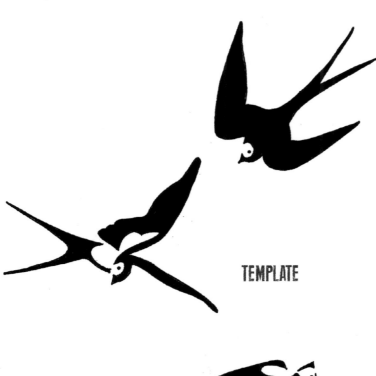

TEMPLATE

- Embroidered linen, washed and ironed
- Scissors (for fabric and paper)
- Fabric for reverse side of cushion
- Tracing paper
- Pencil
- Newsprint
- Carbon paper
- Craft knife and cutting mat
- Needle
- Screen and hinged base
- Masking tape
- 4 coins
- Packing tape
- Acetate (optional)
- Water-based fabric inks or paints, or acrylics mixed with textile medium
- Squeegee
- Card
- Old library or bank card and lidded jar
- Sponge
- Iron
- Dry cloth
- Thread to match fabric
- Dried lavender to fill cushion

TROUBLESHOOTING

- If the ink has not gone through to the fabric, try using more pressure with the squeegee. Alternatively it may be too thick and needs thinning with a tiny amount of water.

- If the colour has bled under the stencil, the stencil may have moved or the ink may be too runny - it should be of a creamy consistency. Make sure that the stencil is fixed firmly in place to the screen after the first print. Add extra masking tape if necessary.

INSTRUCTIONS

PREPARING THE FABRIC

1: Using fabric scissors, cut the embroidered linen and the fabric chosen for the back of the cushion to the desired size, including $3/8$in (1cm) all round for the seams. Mine measured 11 x 8in (28 x 20.25cm) including the seam allowances, but the cushion can be made larger or smaller, if preferred. Make sure the lines cut are straight.

CUTTING THE STENCIL

2: Enlarge or reduce the swallow template on page 77 to fit your fabric, or use your own artwork. Cut tracing paper to the size of your fabric and trace around the lines of the embroidery as a guide to help work out exactly where to position the print. Take into consideration the best placement of the artwork on the embroidered fabric. Finally, trace the design onto the tracing paper.

3: Cut the newsprint to size and transfer the design by slipping carbon paper, carbon-side down between the tracing paper and newsprint. Trace over the outlines with a pencil. Using a sharp craft knife and cutting mat, carefully cut the areas of the design from the newsprint that are shaded in black on the template. If the eyes of the birds are too fiddly to cut with the craft knife, push a sewing needle through the paper to make the holes.

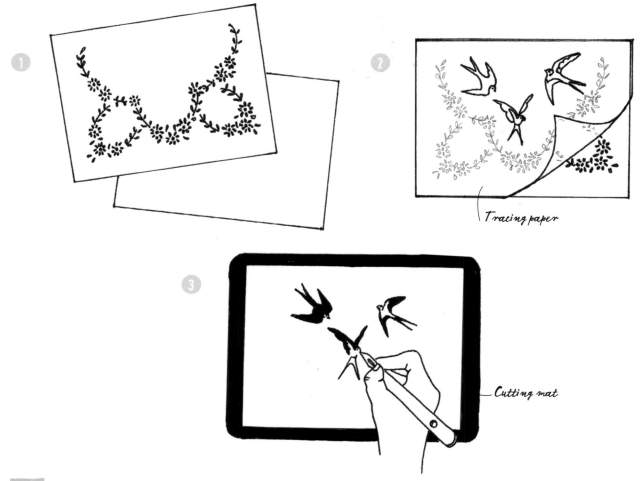

Tracing paper

Cutting mat

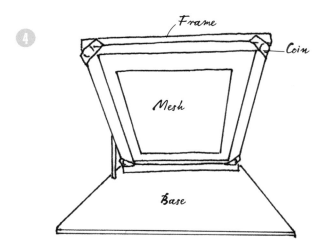

④

Frame
Coin
Mesh
Base

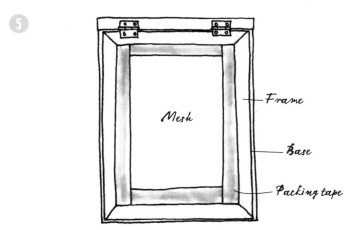

⑤

Mesh
Frame
Base
Packing tape

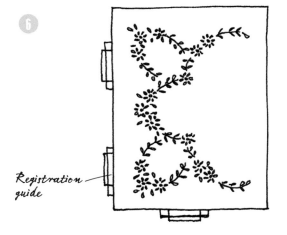

⑥

Registration guide

PREPARING THE SCREEN

4: Attach the screen to the hinged base (see page 52). Use masking tape to stick coins to each corner of the underside of the screen to raise it slightly and help prevent it sticking to the fabric.

5: Cover the inside edges of the mesh and a little way up the frame of the screen with packing tape to prevent any excess colour seeping between the frame and the mesh onto the fabric. Lay the fabric you are printing under the screen, lowering the screen to check the design is not too near the edges and allowing a margin all around of approximately 1in (2.5cm). When you are happy with the position of the fabric, cover any exposed areas of the screen around the cut shapes in the stencil with more masking tape or with acetate (which can be washed down and re-used). Carefully lift the screen so the edges can be registered if you wish to print more than one piece of fabric of the same size.

REGISTRATION

6: Cut three rectangles from the card and, using masking tape, stick two of the lengths against the long edge and the third at the shorter edge, butting the straight edges up against the fabric. Make sure the edges that are placed against the fabric are not the edges that you have cut, but the actual edges of the card, to ensure the registration is accurate.

PRINTING

7: Prepare the ink, following the manufacturer's instructions if using a textile medium. The inks should be of a creamy consistency. Secure the fabric to the base with masking tape so it does not stick to the screen. Lay the stencil in place on the fabric and carefully lower the screen. Spoon a line of ink across the end of the screen that is nearest to you. Lift the screen a little and use the squeegee to push the ink across the mesh to the back of the screen. This coats the screen, making it ready for printing the fabric.

8: Lower the screen. With the squeegee at a 45-degree angle to the mesh and using both hands, pull the ink back towards you, maintaining an even pressure. This will push the colour through the mesh onto the fabric. Raise the screen and push the line of ink to the back of the screen again, ready for the next print. (See Troubleshooting, page 77.) Remove the printed fabric to an area where it can dry.

9: The ink will have stuck most of the stencil to the screen, but the corners may need sticking down with masking tape before you continue printing. This helps keep it in place as it can move slightly as you print.

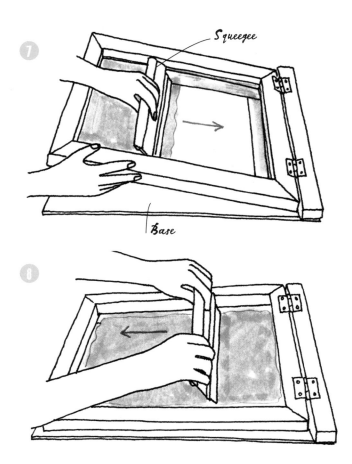

CLEANING UP

10: The screen should be washed immediately after use to prevent any ink drying on the mesh. Remove any excess ink from the screen. An old library card or bank card is handy for scraping up the ink, which can be saved in a clean, lidded pot or jam jar for future use. Remove the stencil and masking tape and detach the screen from the hinged base. Use water and a sponge to thoroughly wash the screen and allow it to dry naturally.

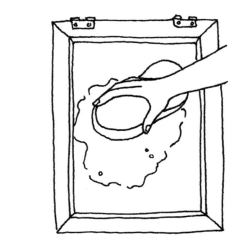

FIXING THE PRINT

11: Once the printed fabric has dried, fix the ink with an iron set at the highest heat suitable for the fabric. Put a dry cloth over the fabric and iron well for a few minutes on both sides.

MAKING UP THE CUSHION

12: With right sides of fabric together, sew around the edges on a sewing machine or by hand using tiny stitches close together so the lavender won't slip through. Leave an opening of around 4in (10cm). Cut diagonally across the corners, taking care not to cut the stitching. This will allow the seams to lay flat. Turn right side out and fill the cushion with the dried lavender or a mixture of lavender and flax seed, which will give it a nice weight. Turn under the raw edges at the opening and sew together by hand or machine to close.

MONOPRINTING

A monoprint is an artwork that is transferred from one surface to another to create a mirror image of the original. Monoprinting is the most 'painterly' form of print making; colour and lines are painted and drawn freely so, although the work can be repeated, no two are the same. The image can also be re-worked in between each print to introduce colour and detail, using brushstrokes or marking the surface with fine lines and removing areas of ink with a rag.

Many artists have used monoprinting. Edgar Degas (1834-1917) experimented with shadow and light by wiping away and adding colour to the plate using rags, brushes and his fingers to produce a rich, tonal quality. Paul Gauguin (1848-1903) and Paul Klee (1879-1940) used the tracing method. Paper was coated with an even layer of ink and a clean sheet of paper placed over it. The artist would draw on the top of the fresh paper and the pressure of the drawing tool would transfer the ink to the underside of the top sheet of paper.

This form of print making provides the artist with the freedom to be spontaneous and expressive, to have fun experimenting with it and to combine it with other techniques and media.

TOOLS AND MATERIALS

RUBBER BRAYER

Rubber brayers are used for block printing. The ink is rolled on a palette to coat the brayer before coating the block with an even layer. Available in various sizes, use one that is large enough for your project. Keep it clean after use and out of the sunlight, as the rubber will become brittle and crack.

HAMMER

The hammer is applied to print making in this chapter, gently tapping the pigment from leaves and flowers to transfer the colour to fabric. Rubber or wooden mallets don't work as well, so use a metal hammer.

POLYSTYRENE SHEET

These sheets are great for monoprinting. They can be used as blocks, scoring into them with biros, then rolling with ink and pressing onto paper to print. They make ideal projects for children, as there are no sharp carving tools involved. They can be cut into shapes and used as stamps.

GELATINE

Gelatine is commonly used as a food agent but it is ideal for monoprinting. Areas of the gelatine plate can be cut away and, as the plate deteriorates, cracks appear that add interesting textures to subsequent prints. It is easy to clean and can be re-used if wrapped in cling film and stored in the refrigerator. When the paper is pressed onto the inked-up plate, the natural suction of the gelatine means the ink transfers easily. A shallow container for making the gelatine plate needs to have sides of around $3/4$in (2cm) high, such as a tray or baking tin. An acrylic sheet can also be used with sides built up using modelling clay.

INK

Water-based block-printing ink and fabric paint are used in this chapter. Colours can be mixed on a paint palette using an ice lolly stick. Make sure that the fabric paints are not runny; they should be of a creamy consistency.

PAPER

Monoprinting is a very free and expressive form of printing. Have fun experimenting with different papers and surfaces. Each print will be unique and you may find that certain materials suit the style in which you work better than others.

AEROSOL VARNISH

Applying varnish to your printed project will provide a protective layer against dust and moisture; this is especially suitable for the Place Mats on page 101, which will see a lot of use. Choose an archival varnish which will not yellow with age and a product that has UV filters. Test the varnish on similar materials to see how it appears before applying to the finished piece.

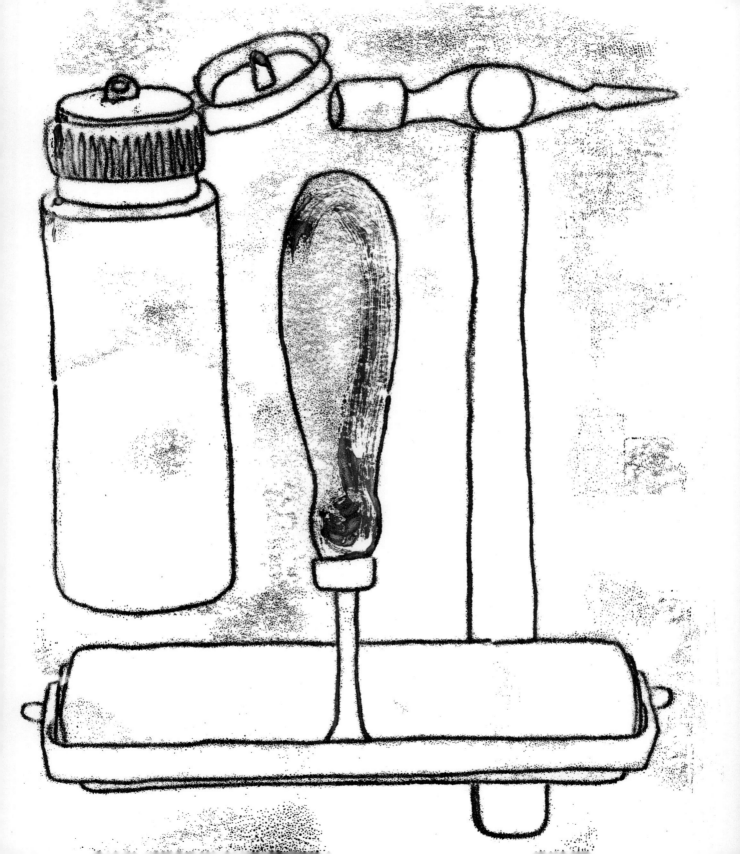

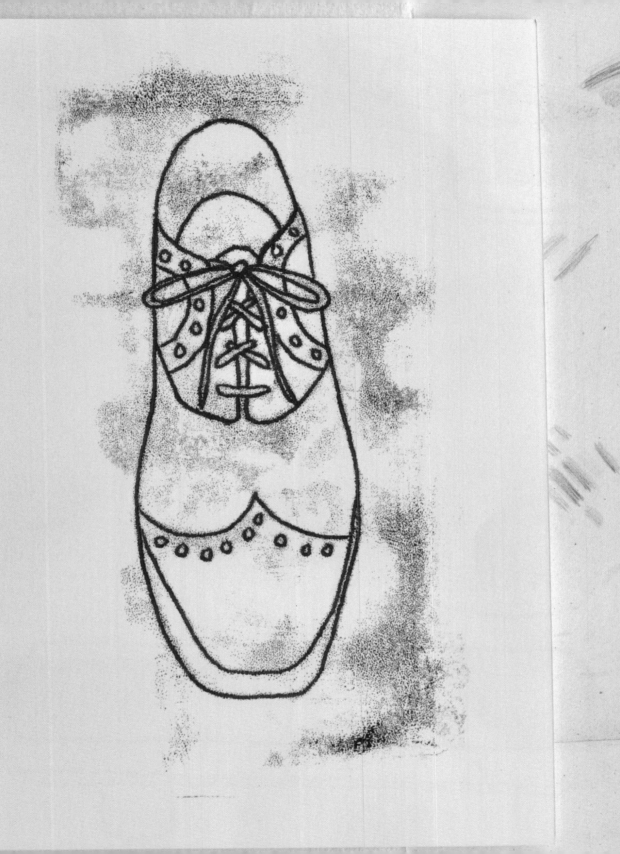

BASIC MONOPRINT

The method of traced monoprinting is similar to making carbon copies of an artwork. Each one will turn out slightly different. Experiment with printing on paper or use fabric to make these eye-catching shoe bags.

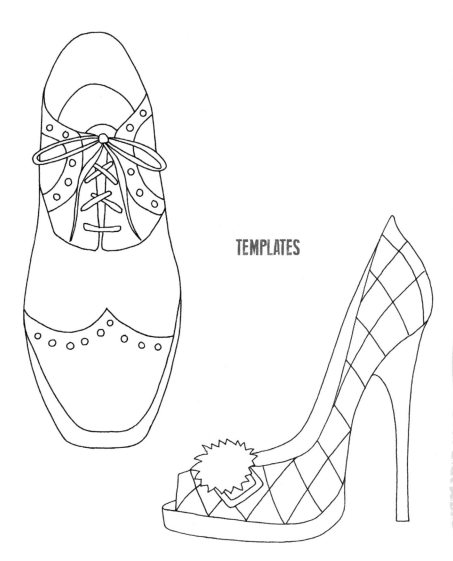

TEMPLATES

TOOLS AND MATERIALS

- Newsprint or brown paper
- Masking tape
- Pencil or ball-point pen
- A4 sheet of acetate
- Block-printing ink
- Paint palette
- Rubber brayer
- A4 sheets of cartridge paper
- Bone folder or wooden spoon
- Paintbrush

FOR THE SHOE BAG

- Thick paper or card
- Cotton shoe bags for each design measuring around 16½ x 10in (42 x 26cm)
- Water-based fabric ink or paint, or acrylic mixed with textile medium
- Spoon
- Iron
- Dry cloth

TROUBLESHOOTING

- If the lines of the image on the shoe bag are thick and blurred, the fabric ink has probably started to dry and adhered to the material. Try rinsing the bag under warm water. The excess ink should wash away leaving you with the intended lines of the artwork. Leave it to dry and fix the fabric ink with an iron over a dry cloth.

INSTRUCTIONS

TRANSFERRING THE DESIGN

1: Enlarge one of the templates on page 87 to around 9 x 5¼in (22.5 x 13.5cm) or use your own artwork. Cover the work surface with a large sheet of newsprint or brown paper to protect it. Use one long strip of masking tape to stick the long side of the acetate to the newsprint to act as a hinge. Use a few small strips of masking tape to attach the template to the front of the acetate.

PRINTING

2: Squeeze a small amount of block-printing ink onto the paint palette and roll the brayer through it. Turn the acetate and roll a thin layer of ink evenly over the surface of the reverse side. Place a piece of paper on the work surface and carefully turn the acetate sheet so it lies, ink-side down, on the paper.

3: Use a ball-point pen or pencil to trace over the template that is attached to the acetate sheet. Do not put pressure on the acetate other than the marks you intend to make over the design. This will transfer the ink from the acetate onto the paper. When you have finished, turn the acetate back on its hinge and move the printed paper to one side to dry. The process can be repeated to make a number of prints. Each print will be fainter than the last so the ink on the acetate will need recharging depending on the number of prints you wish to make.

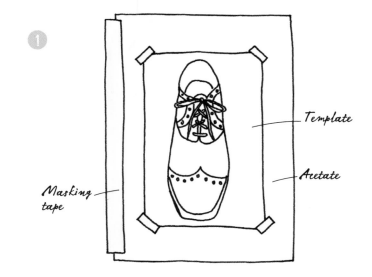

Template

Acetate

Masking tape

Reverse side of acetate

Paper

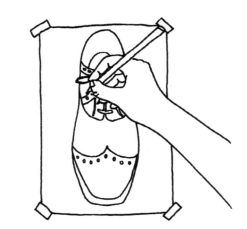

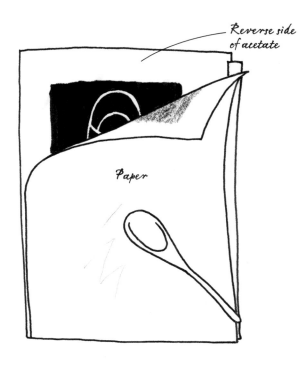

④ Reverse side of acetate

Paper

4: After working on the first monoprint, an imprint of the artwork will appear on the inked side of the acetate where the pigment has been transferred onto the paper. By laying paper over the acetate and burnishing the back of it with a bone folder or wooden spoon, a print may be taken directly from the acetate. The image will appear paler and in reverse. This is called a ghost print.

5: If the acetate is holding enough ink, more colours can be applied to add detail using the paintbrush and the lines as a guide. Another sheet of paper can be placed under the acetate and the template traced again to produce a variation of the original artwork.

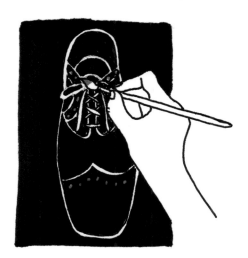

⑤

TIP
Use different tools to produce various effects. A sharp pencil will make a fine line, whereas rubbing the paper with a fingertip will create a smudged impression. Have fun experimenting with other mediums such as watercolours.

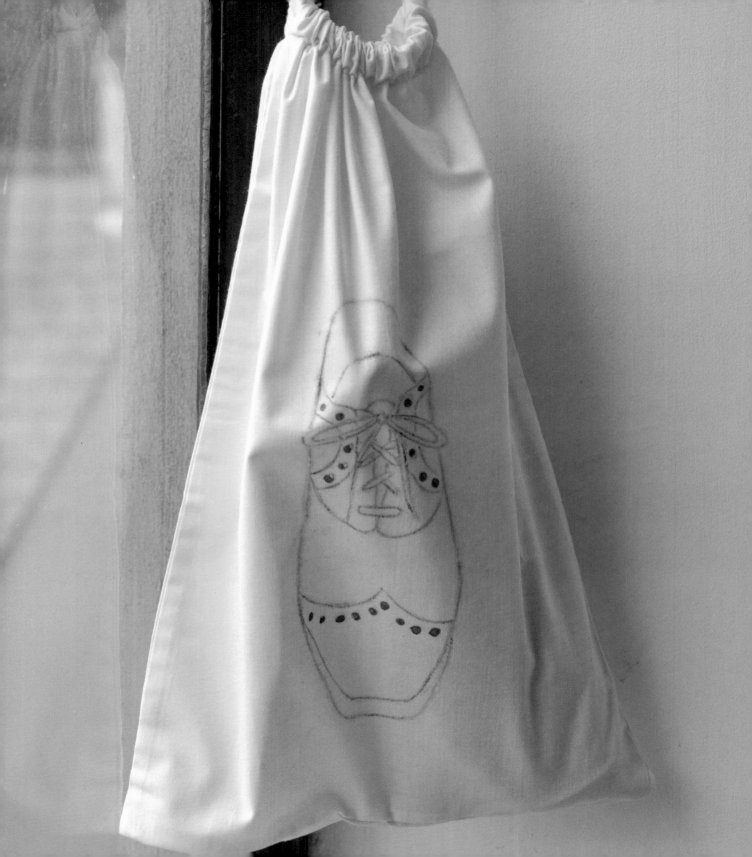

MONOPRINTING A SHOE BAG

1: Insert a piece of thick paper or card inside the bag so the inks do not seep through to the back. Follow Step 1 on page 88 to get ready for printing.

2: Prepare the colour, following the manufacturer's instructions if using a textile medium. Spoon a small amount onto the paint palette and roll out with the brayer. Then roll an even coat of the fabric ink over the back of the acetate. Place the shoe bag on the work surface and carefully turn the acetate sheet so it lies, ink-side down, on the bag (see Troubleshooting, page 87).

3: Follow Step 3 on page 88 to print the image onto the bag in the main colour, which will provide the guidelines on the reverse side of the acetate for painting in the details with other shades. Use the techniques in Step 5 to print the bag with coloured detail. Try using your fingertips, as well as the pen or pencil, to transfer the additional colours from the acetate onto the bag.

4: When the ink has dried, set the iron at the highest heat suitable for the fabric. Put a dry cloth over the fabric and fix the print by ironing well for a few minutes on both sides.

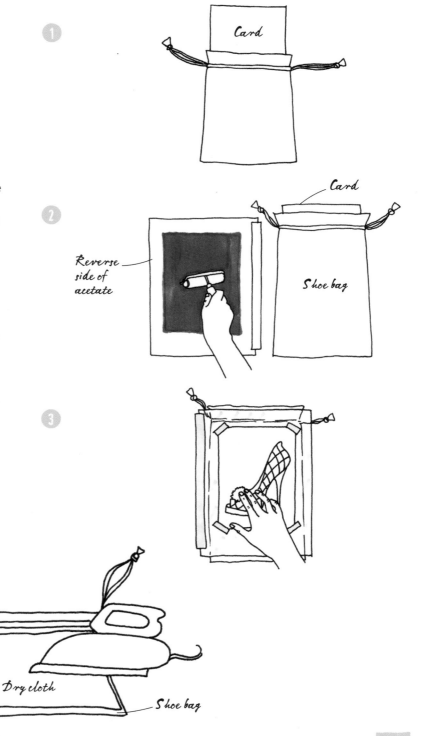

Card

Card

Reverse side of acetate

Shoe bag

Dry cloth

Shoe bag

TEA TOWEL

Create the effect of a wall of faded, decorative tiles by using this method of monoprinting. Choose to either repeat a single pattern or produce a variety of different designs to create a mix-and-match effect.

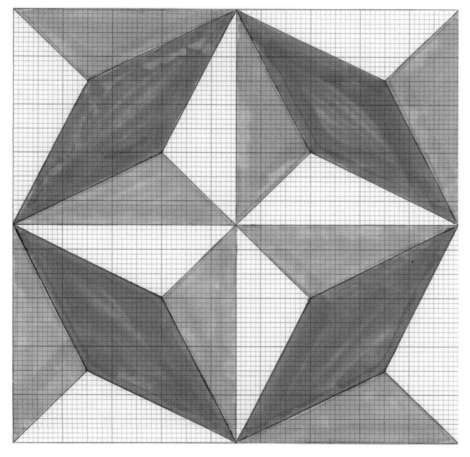

TEMPLATE

TOOLS AND MATERIALS

- Tracing paper
- Ruler
- Soft pencil
- A2 sheet of graph paper or A4 sheets taped together, the lines of the graphs matching
- Coloured pens or pencils
- 4 x 4in (10 x 10cm) polystyrene sheet (or to fit repeated shapes from your own artwork)
- Scissors
- Acetate or cellophane, a little larger than the graph paper
- Craft knife
- Cutting mat
- Card (such as a postcard)
- Cotton or linen tea towel, washed and ironed
- Masking tape
- Newsprint
- Water-based fabric ink or paint
- Spoon
- 3 rubber brayers
- Paint palette
- Iron
- Dry cloth

TROUBLESHOOTING

- Before placing the acetate over the tea towel, check the first few rows of the pattern have not dried; if need be, they can be re-printed before continuing.

- If the print is patchy, it has probably dried out on the acetate. Work quickly.

- The finished tea towel can be touched up using the polystyrene shapes coated with ink. But, as the print appears in reverse, the shape used for printing the grey needs to be re-cut to mirror the one used on the acetate.

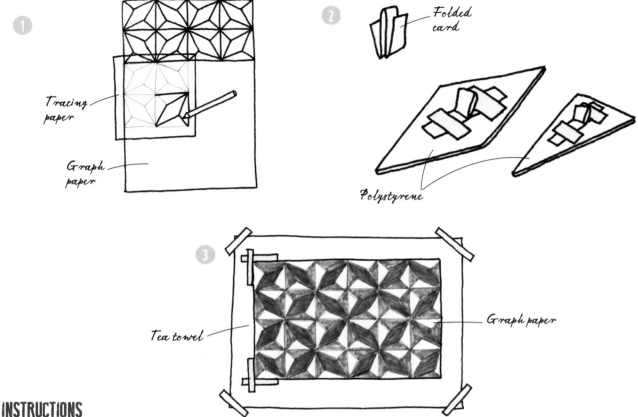

1

Tracing paper

Graph paper

2 Folded card

Polystyrene

3 Tea towel

Graph paper

INSTRUCTIONS
CREATING THE DESIGN

1: Enlarge the template on page 93 to 7 x 7in (18 x 18cm) or use your own artwork. Trace the design using a ruler and a soft pencil. Flip the tracing paper over and line up the pattern against the corner of the graph paper. Follow the lines with a pencil and ruler on the reverse side of the traced image to transfer the pencil marks to the graph paper. Now flip the tracing paper over again, line it up next to the first pattern on the graph paper and transfer the pencil lines as before. Continue until the pattern has been repeated six times on the graph paper. Colour the pattern with pencils or pens.

2: Use the traced artwork to transfer the lines onto the polystyrene sheet by scoring them with a sharp pencil or scissors. As there are just two colours and shapes repeated on the template, only those two shapes need to be cut out. Cut them carefully from the polystyrene with a craft knife on a cutting mat. With scissors, cut a narrow strip from a card for each polystyrene shape. Fold each in half and turn back each end to form a 'W' shape. Use masking tape to attach each turned end to the polystyrene shape to make a handle.

3: Cover your work surface with newsprint to protect it. Lay the tea towel to one side of the work surface and tape it down with masking tape. Place the graph paper over the right side of the tea towel and apply two strips of masking tape against both of the top corners of the paper, allowing the acetate to be positioned correctly when you are ready to print.

PRINTING

4: Place the graph paper with the design facing up onto the newsprint. Lay the acetate over the graph paper, leaving a border all around. Use a few strips of masking tape to secure it to the newsprint. Spoon a small amount of each colour of the fabric ink onto the paint palette. Use a separate brayer for each colour to roll out an even coating on the palette. Use the brayer to coat the polystyrene shape with the colour, or press it into the ink on the palette. Press the inked polystyrene onto the acetate, matching the shape with the design on the graph paper beneath. Work from top to bottom, printing a line of one colour and then the next. This way you won't smudge the colour.

5: When the whole design has been printed onto the acetate, lift it from the work surface and line the top corners of the print with the masking tape on the tea towel. (See Troubleshooting, page 93.) Lower the acetate onto the tea towel. Do not move it once it is in contact with the fabric, as this will smudge the design.

6: Use a clean, dry brayer to roll over the back of the acetate to transfer the ink to the fabric. Lift the corner of the acetate to check the print has transferred, replacing it and rolling the brayer over again if necessary. Remove the acetate from the tea towel and leave to dry. (See Troubleshooting, page 93.) Fix the print with an iron set at the highest heat suitable for the fabric. Put a dry cloth over the tea towel and iron well for a few minutes on both sides.

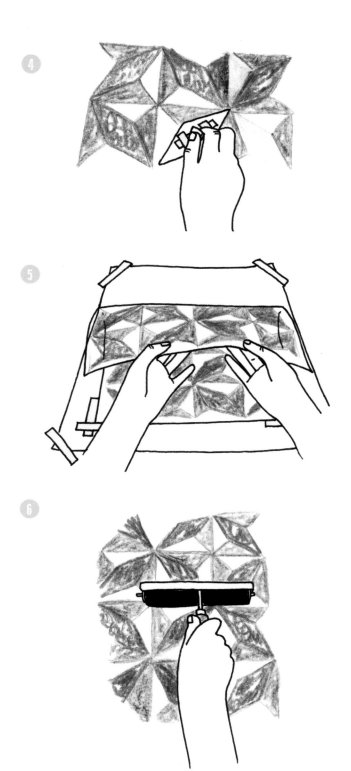

SILK SCARF

Enhance a plain silk scarf with the help of
Mother Nature by utilizing the natural pigments
in flowers and leaves picked from your garden.

TOOLS AND MATERIALS
- Newsprint or brown paper
- Plain silk scarf, ironed
- Leaves and flowers (such as ferns and violas)
- Paper towels
- Hammer
- Iron

TROUBLESHOOTING
- If the scarf is very sheer, another piece of fabric can be laid beneath it as the colour from the plants will go through both, resulting in a second printed piece. Experiment with different fabrics. Printing on heavier cottons will produce a stronger image.
- If parts of the leaf and petals adhere to the transfer, they can be lifted off. Take care not to smudge the colour as you do this. Alternatively, they can be left to dry and simply brushed away.
- If printing on a bag or T-shirt, place paper or card inside to prevent the print going right through to the back.

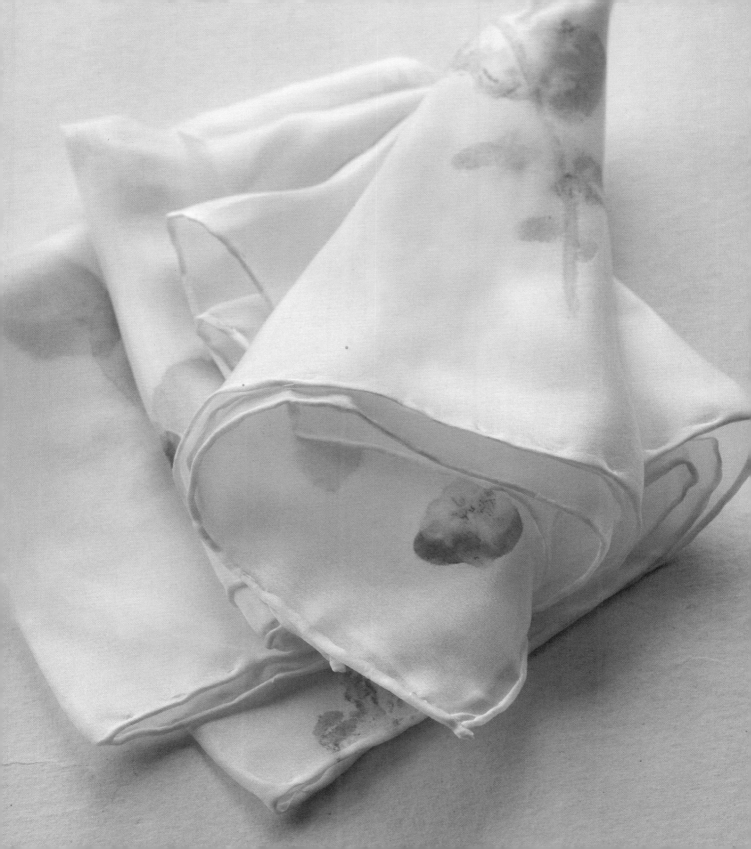

INSTRUCTIONS

PREPARE THE SURFACE

1: Choose a smooth, hard surface to work on. Lay the newsprint or brown paper over the work surface. This is to prevent the colour from the plants seeping through the fabric and staining the surface underneath. Lay the scarf on the newsprint (see Troubleshooting, page 96) and smooth out the area on which you are about to print.

2: Place a leaf or flower onto the fabric. The flower should be placed face down, but leaves can be placed either way.

PRINTING

3: Lay a paper towel over the leaf or flower and tap lightly with the hammer. Begin at the stem of the leaf, following it through the middle. The line will appear through the paper towel. Keep working on the rest of the leaf until the whole shape can be seen. With the flower, start from the edges and work your way to the centre.

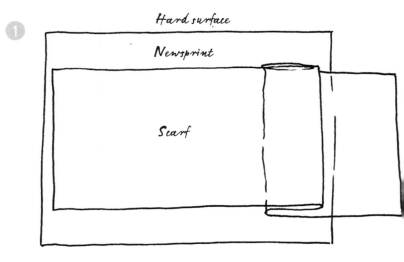

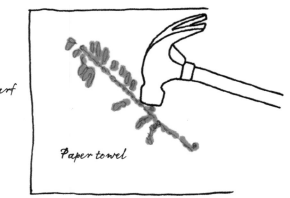

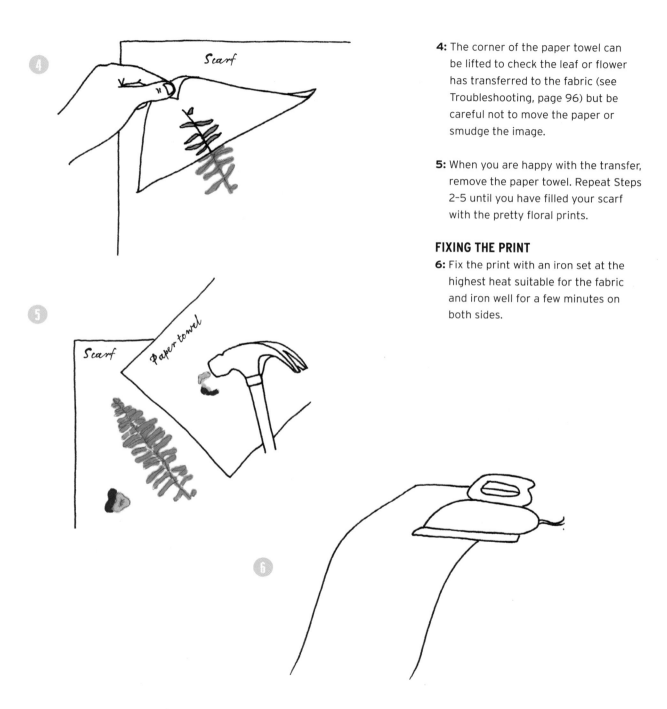

4: The corner of the paper towel can be lifted to check the leaf or flower has transferred to the fabric (see Troubleshooting, page 96) but be careful not to move the paper or smudge the image.

5: When you are happy with the transfer, remove the paper towel. Repeat Steps 2–5 until you have filled your scarf with the pretty floral prints.

FIXING THE PRINT
6: Fix the print with an iron set at the highest heat suitable for the fabric and iron well for a few minutes on both sides.

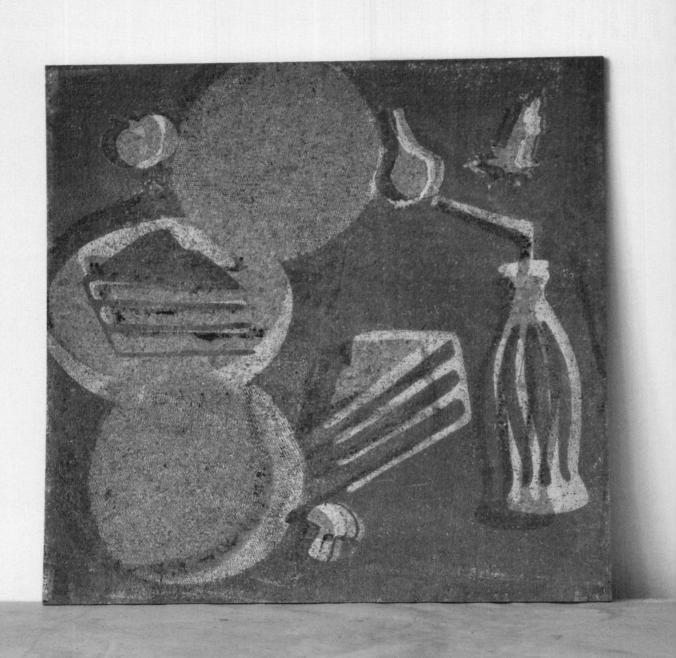

PLACE MATS

As well as using stencils and textures produced by materials found around the home, the surface of a gelatine plate can be cut into to create interesting designs for your print making.

TOOLS AND MATERIALS

- Tray or baking tin with sides around ³⁄₄in (2cm) high
- Measuring jug
- Gelatine
- Tablespoon
- Kettle
- Bowl
- Balloon whisk or fork
- Strip of paper
- Cling film
- Tracing paper
- Pencil
- Carbon paper
- Newsprint
- Craft knife and cutting mat
- Block-printing ink
- Paint palette
- Objects to provide texture and shape, such as net fabric and cookie cutters
- 2 rubber brayers
- Cork floor tiles
- Sponge
- Aerosol varnish

TROUBLESHOOTING

- If the plate falls apart when lifting it from the tray, you may not have added enough gelatine. It should be a yellow colour. I kept mine in the container because it was larger than the tiles I was using so the edges of the tray would not interfere with the printing. This way, the plate can be moved around easily as well.
- If the print has smudged, the plate may be wet after cleaning it. Blot any excess water with newsprint and leave to dry.

TEMPLATE

INSTRUCTIONS
MAKING THE GELATINE PLATE

1: Fill a measuring jug with water. Place the tray on a level surface and fill it just over half way with water from the measuring jug, taking note of how much water it takes; this will determine the amount of gelatine you will need to make. For every 8fl oz (250ml) of water poured into the tray, you will need two tablespoons (30ml) of gelatine. Boil half the amount of water and leave the other half cold. I used a tray that held around 2½pt (1.5l) of water. This meant I needed 12 tablespoons (180ml) of gelatine with 1¼pt (750ml) each of cold and hot water.

2: Pour the cold water into the bowl, add the gelatine and whisk. Slowly add the boiling water, stirring all the time with a balloon whisk or fork until the gelatine has dissolved. Pour the gelatine mix into the tray. Skim any bubbles from the top of the gelatine by drawing a strip of paper across the surface. Leave the gelatine to one side to set. It can then be carefully removed from the tray (see Troubleshooting, page 101), wrapped in clingfilm and kept in the refrigerator for some time.

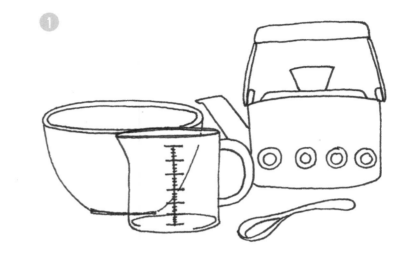

Paper

Tray

> **TIP**
> Do not pour any excess gelatine down the drain as it will harden and cause a blockage. Pour it into a cup or bowl and leave to set before discarding it.

> **TIP**
> After a while the gelatine plate will begin to decay, but it can be re-used – the cracks that appear will add interest to future prints.

CUTTING THE STENCILS

3: Enlarge the template on page 101 or use your own artwork and copy the design onto the tracing paper. Slip carbon paper, carbon-side down, between the newsprint and tracing paper and trace over the outlines with a pencil to transfer the design.

4: Use a sharp craft knife and cutting mat to carefully cut out the stencils from the newsprint. I used the stencil of the cake on the plate, which was cut from the black area of the template, and the white cake shape, which I removed from the stencil. This meant that I had two stencils, which gave me different results when printed.

5: As well as placing stencils onto the surface of the plate, the gelatine itself can be cut into, providing added interest to the final print. Cookie cutters are ideal. The printed image will appear in reverse, so with this in mind, work out where the stencils would be placed and then press the cookie cutters into the background areas of the gelatine. Carefully remove the cut shape from the plate.

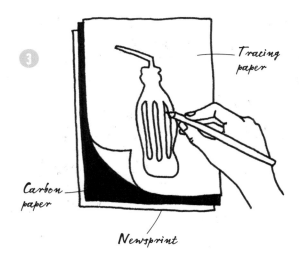

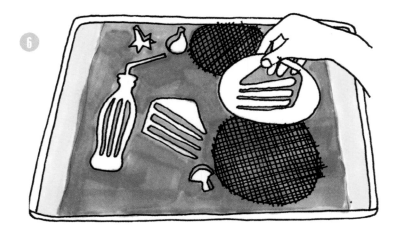

PRINTING

6: Squeeze a small amount of ink onto the paint palette. Roll the brayer through it and then roll an even layer of ink over the surface of the gelatine block. Texture can be achieved by placing items such as net, lace, doilies, string and plant matter onto the inked-up plate. Lay the stencils and other materials you are using on the plate.

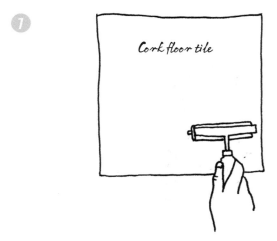

Cork floor tile

7: Use the back of the floor tile to print on. This side is untreated, providing a more absorbent surface for the ink, which results in a sharper print. If it has a serial number printed across the middle, it can be rubbed away with a dry rag. Lay the tile onto the inked plate. Using the clean, dry brayer, roll over the back of the tile to make sure it makes even contact with the gelatine plate. Lift the plate and put to one side to dry.

Sponge

8: Remove the stencils and other materials. Clean the ink from the plate with water and a sponge. Blot the excess water from the plate with newsprint and leave to dry before adding the next colour. (See Troubleshooting, page 101.) Layering two or three colours will give interesting results and each place mat will be unique, particularly as the stencils may not be replaced in exactly the same area each time. When the ink has dried on the cork, seal with an aerosol varnish.

SUN PRINTING

Certain chemicals when coated onto paper and exposed to sunlight create a beautiful blueprint effect, called sun printing or 'cyanotype'.

In 1842 the scientist and astrologer Sir John Herschel, when trying to make copies of his notes, discovered cyanotype. The chemicals ferric ammonium citrate and potassium ferricyanide produce a solution that is coated onto paper and exposed to ultraviolet light. When the exposed paper is washed in water, the result is a blueprint. The exposed areas of the finished print turn a beautiful Prussian blue and any unexposed details remain white. An English botanist, Anna Atkins (1799-1871), was the first to use cyanotype to produce photographic images. She is considered to be the first woman photographer. She used cyanotype to record specimens of algae, flowers and ferns.

Cyanotype is very versatile and does not have to be restricted to paper. The solution can be coated onto other surfaces such as wood and textiles. The natural Prussian blue can be altered to create yellow tones by submerging it in water in which there is detergent containing phosphates. After rinsing, this can then be immersed in a strong black tea, rinsed again and left to dry, producing a sepia print.

Some projects in this chapter use light-sensitive fabric dyes and a solar plate. Transparencies and photographic negatives, stencils, objects such as lace, safety pins and feathers are just a few things that can be used to create a sun print.

TOOLS AND MATERIALS

BOARD

A plywood board is ideal to use as a base for your sun prints. Lay a piece of black cartridge paper over the board to block the light, preventing the sun from bouncing back through the light-sensitive paper. The board and paper should be larger than the light-sensitive material you are using.

GLASS

A sheet of glass that is not UV-protected should be placed over the light-sensitive paper or fabric on the top of the board and paper (see above) to keep the paper from curling or moving during exposure. Make sure the glass is clean, as fingerprints and dust particles can affect the print. The glass should be larger than the light-sensitive material you are using.

BRUSHES AND BRAYERS

Light-sensitive dye can be painted onto fabric using an interior decorating paintbrush, foam brayer or a foam brush, which consists of a sponge on a wooden handle and is available in different sizes. Sensitizer solution can be painted on using an artist's paintbrush, or applied with a glass rod or J-cloth. A rubber brayer is used to coat the solar plate with oil-based block-printing ink.

LIGHT-SENSITIVE DYE

This dye reacts to UV light so it is applied to the surface in a darkened or dimly lit room. The dye can be washed out before exposure to UV light, but once it has been exposed it is permanent. Objects or transparencies are used to create images on the material, as the areas that they cover will not be exposed to the light. The fabric is washed after exposure, removing the unexposed dye from the covered areas to create an image.

INK

Artwork can be painted directly onto acetate with India ink using a brush or fountain pen. Images can be traced by laying the artwork underneath the acetate and following the lines. India ink is lightfast but you need to hold the finished acetate up to a window to check for any areas that may need filling in.

SAFETY
Always use protective gloves, such as surgical gloves, eyewear and an apron when handling chemicals and keep them out of the reach of children.

CITRIC ACID

To create better contrast in a cyanotype print, the developed paper can be added to a bath of citric acid powder or crystals dissolved in water. However, it is important to wash the print out fully when it is removed from the citric acid bath to prevent fading. As the paper dries, the print will become clearer and the Prussian blue colour will intensify. White vinegar and a weak hydrogen peroxide bath can also be used to enhance the tones of a cyanotype print.

SENSITIZER SOLUTION

The sensitizer solution is a mix of ferric ammonium citrate and potassium ferricyanide, which is available ready prepared or can be mixed at home. It must be kept in a cool, dark place in an amber glass bottle. The sensitizer is applied in subdued lighting. It is important to coat the paper evenly and be aware that it may need two coats, especially if the sensitizer is applied using a J-cloth. Leave it to dry in the dark, after which it can be exposed.

WORK SURFACE PROTECTION

The dyes are permanent, so you will need to cover your work surfaces with newsprint, newspaper or brown paper.

PAPER

BLACK CARTRIDGE PAPER

Stencils can be cut from black cartridge paper as it is lightfast and ideal for sun printing. Use a craft knife and cutting mat to cut the paper stencil. The stencil can be used alone or adhered to acetate with adhesive and is good for large areas that require blocking from the light. Both stencils and drawing with India ink can be used together to create one transparency.

ACID-FREE PAPER

Choose a paper that is acid-free and heavy enough to withstand plenty of washing during development and still hold its shape. If there are impurities in the paper, it will change from bright yellow to green or blue during the time it is left in the dark before exposure. A heavyweight cotton watercolour paper is well-suited to cyanotype printing.

CYANOTYPE PAPER (AND FABRIC)

Pre-coated cyanotype paper and fabric are widely available. This means you can get printing straight away. Packaged in a UV-resistant bag or envelope, they should be kept away from light until you are ready to print.

TRANSPARENCIES

ACETATE

Transparencies are clear sheets that can be printed or hand-drawn using a lightfast ink. This produces a negative that will print as a positive when placed on light sensitive paper or fabric and exposed to UV light. Acetate is ideal for this purpose.

PHOTOGRAPHIC NEGATIVE

A photographic negative can be printed onto contact film for ink-jet printers, available to buy from photographic suppliers and stationers. Alternatively, your chosen negative can be taken to a copy shop to be printed as a transparency. Be aware that the negative needs to be the size of the final print.

SOLAR PLATE

A solar plate is a steel sheet coated with a light-sensitive polymer material. The plate can be worked on directly or exposed through a transparency, such as acetate or a photographic negative (see above). It is exposed to the sun and developed in water. The solar plate should be kept in a UV-resistant bag. Rub a little oil on the surface of the plate to protect it.

NATURAL MATERIALS

Light-sensitive dye works best on natural fibres, such as cotton, linen and silk. It can also be used on wood. If you are working on detailed prints, use a material with a smooth surface.

OBJECTS TO CREATE PATTERNS

Many found objects can be used to create patterns. Choose articles that have contact with the surface as any raised areas will create shadows that will affect the finished image. Leaves, feathers, lace and machine cogs will make interesting prints.

SUNSHINE!

Always check the manufacturer's instructions for development time of the light-sensitive fabric dyes, solar plate and cyanotype prints. Sun printing works best under strong sunlight. Exposure time is dependent on the light. Strong sunshine will speed the process up, whereas on an overcast day, the exposure time may take at least twice as long.

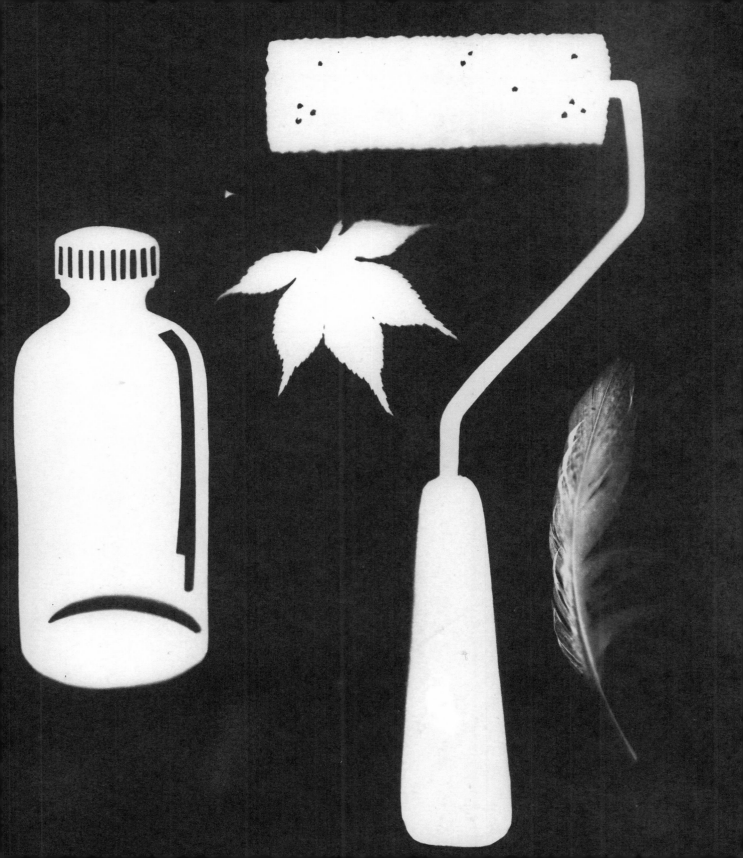

BOOK COVER

Cover a plain notebook or diary with a unique dust jacket.
The inside flaps can also be used as handy pockets to store business cards or inspirational cuttings.

TOOLS AND MATERIALS

- Light-sensitive dye
- Apron
- Gloves (optional)
- Paint palette
- Paintbrush or sponge brayer
- Paper towels
- 20 x 10in (51 x 25cm) natural fibre fabric, such as cotton or linen, washed, ironed and hemmed
- Dressmaker's pins
- Board (such as sturdy card) covered in plastic (such as a bin bag)
- Objects, such as Meccano ®, cogs and keys (see Troubleshooting, below)
- Laundry detergent
- Iron
- A5 hardback notebook
- Sewing machine or needle (if stitching by hand)
- Matching thread

TROUBLESHOOTING

- Choose objects that lie flat on the surface of the fabric. Those with height tend to cast shadows and will distort the shapes in the print.
- If areas of fabric have been accidentally coated with the dye, wash the fabric before it is exposed to the light. When the fabric is exposed, the colour is permanent and cannot be removed.
- If the areas that were covered start to change colour after exposure, rinse under running water directly then wash in hot water with laundry detergent. The fabric needs to be washed thoroughly to remove the residual dye.

INSTRUCTIONS

PREPARE THE FABRIC

1: Refer to the manufacturer's instructions for the light-sensitive dye. Wear an apron as the developed dye is permanent. The dye can be washed off your hands before you take the work outside to expose in the sunlight, or you can wear protective gloves if you prefer. In a darkened room, shake the bottle of dye well before pouring a small amount onto the paint palette. Apply an even layer over the fabric with a paintbrush or sponge brayer (see Troubleshooting, page 113). The solution is very pale prior to exposure. Blot the dye with a paper towel.

2: The edges of the fabric can be pinned or taped to the board to prevent it from curling or being blown by a breeze during exposure. Consider the position of the sun and shadows cast by the pins onto the fabric. Lay the chosen objects, again considering the sun's position (see Troubleshooting, page 113), on the fabric.

EXPOSURE

3: Place the board in direct sunlight to expose the fabric. You will see the colour deepen as it develops.

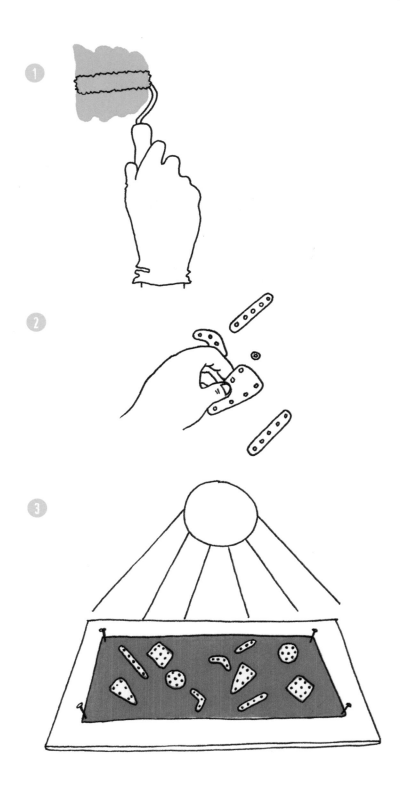

WASHING THE FABRIC

4: Bring the board back to a darkened room and remove the objects. Rinse the fabric under running water to remove any unexposed dye.

5: Machine or handwash, agitating constantly in hot water with laundry detergent. Refer to the manufacturer's instructions for guidelines on washing after exposure. Hang the fabric to dry.

MAKING UP THE COVER

6: Iron the fabric. Lay the book open in the centre on the right side of the printed fabric. Fold each short side over the book cover and pin in place at the top and bottom. Make sure the book closes as the folded ends may be too tight. Remove the fabric and stitch along the pinned seams. Turn right side out and insert the book.

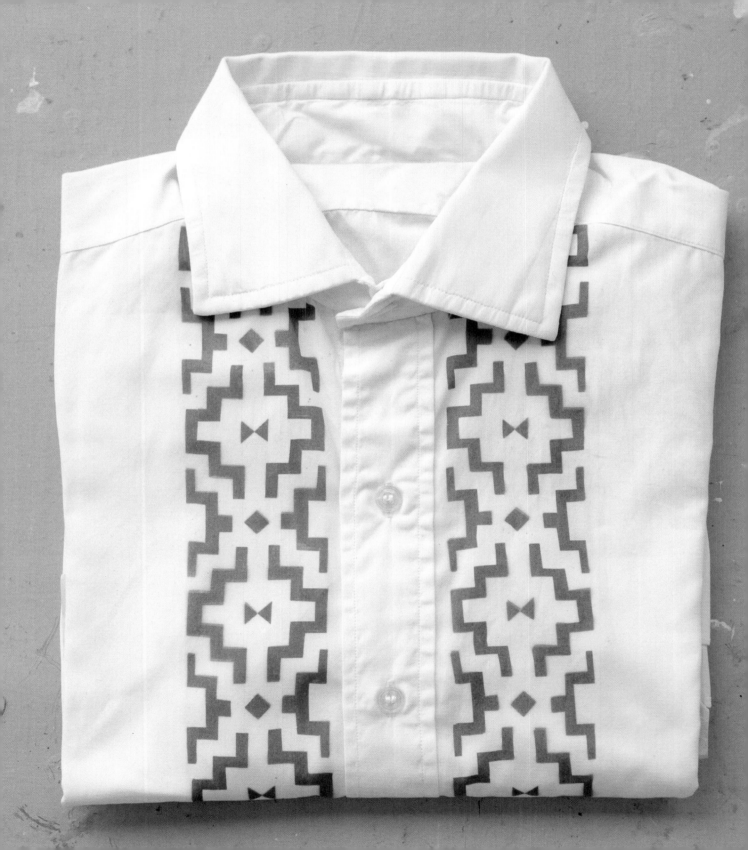

NAVAJO SHIRT

Revamp an old shirt with a geometric pattern and light-sensitive fabric dye. This project was inspired by the beautiful designs of the Navajo, an American Indian tribe in New Mexico and Arizona.

REPEAT

TEMPLATE

TOOLS AND MATERIALS

- Metal ruler
- Craft knife
- Cutting mat
- Black cartridge paper
- Masking tape
- White coloured pencil
- Cotton shirt, washed and ironed
- Acetate to fit the length of the shirt
- Spray mount
- Scissors
- Board (such as sturdy card) covered in plastic (such as a bin bag)
- Apron
- Light-sensitive dye
- Paint palette
- Paintbrush
- Paper towels
- Dressmaker's pins
- Laundry detergent

TROUBLESHOOTING

- If the edges of the design are not crisp, there may be too much dye on the fabric. Also condensation can build under the acetate if the fabric is too wet, causing the edges to blur.
- Make sure the acetate is in contact with the fabric. Add extra pins to keep it in place and prevent it lifting from the shirt, which will also blur the lines of the design.

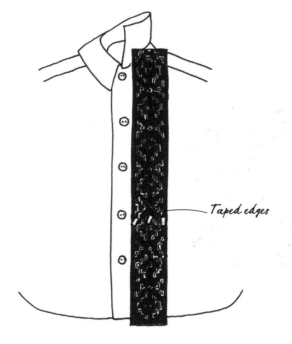

① Black paper

Template

② Taped edges

INSTRUCTIONS
CUTTING THE DESIGN

1: Enlarge and print the template on page 117 or use your own artwork. With a craft knife and cutting mat, cut away the black areas from the template. Use a metal ruler to help with cutting straight lines. Lay the template on the black paper and tape down temporarily with small strips of masking tape to hold it in place. Draw around the cut-out areas with a white pencil to transfer the design.

2: Repeat the design until it fits down the front of the shirt, next to the button band, with extra to allow for the shaping of the neck. If necessary, the paper can be joined with masking tape but make sure the edges overlap to stop light getting through.

3: Use the craft knife to cut out the design from the black cartridge paper. Use the ruler to cut in a straight line. Trim each side of the design down to around 3/8in (1cm).

④

Acetate

4: Repeat Steps 1 and 2 to make another template to match the first. Spray adhesive on one side of each piece of the cut black paper and adhere it to the acetate. Trim the acetate down with scissors.

PREPARING THE SHIRT

5: Button up the shirt and lay it flat with the front facing up. Insert the plastic-covered board to prevent the dye seeping through to the back of the shirt. Tuck the sleeves underneath so that the fabric lies flat. Lift the collar up so it doesn't get in the way.

⑤

Plastic-covered board

6: Apply a line of masking tape down the side of the buttonhole band, around ¼in (0.5cm) narrower than the cut, black paper strip. This will be used as a guide when painting on the dye. Repeat for the button band.

TIP

When attaching the templates to the shirt, only put the pins into the areas that the paper covers. Make sure they do not overhang the cut areas of the paper that will be exposed to the sunlight as they may cast a shadow and affect the print.

⑥

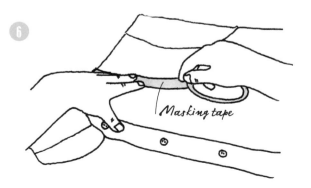

Masking tape

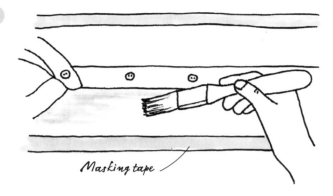

Masking tape

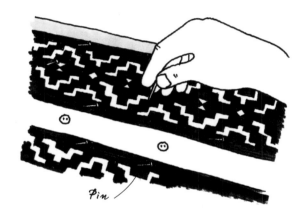

Pin

PRINTING

7: In a darkened room, wearing an apron, pour a small amount of dye onto the paint palette. More can be added if needed. Starting at the edge of the collar, paint a thin coat of dye all the way down the front of the shirt, between the buttonhole band and the strip of masking tape. Do the same for the other side. Blot the excess dye with paper towels.

8: Lay one of the cut designs, with the acetate side facing up, down the front of the shirt between the strip of masking tape and the buttonhole band. It should overlap the collar to allow for the neck shaping. Insert pins into the acetate, through the black paper, shirt and into the board. Pin all the way down each side of the acetate and down the centre of the design, keeping it against the fabric and in line with the edge of the buttonhole band. Ensure the fabric beneath is smooth. Repeat for the other side.

EXPOSURE AND DEVELOPING

9: Place the shirt in direct sunlight to expose. The dye will change colour. When the colour has developed fully, bring the shirt back into the darkened room and remove the pins and templates. Rinse the shirt immediately in running water to remove unexposed dye (see Troubleshooting, page 117). Wash the shirt in hot water with laundry detergent, in a machine or by hand. Follow the manufacturer's instructions for guidelines on washing the prints.

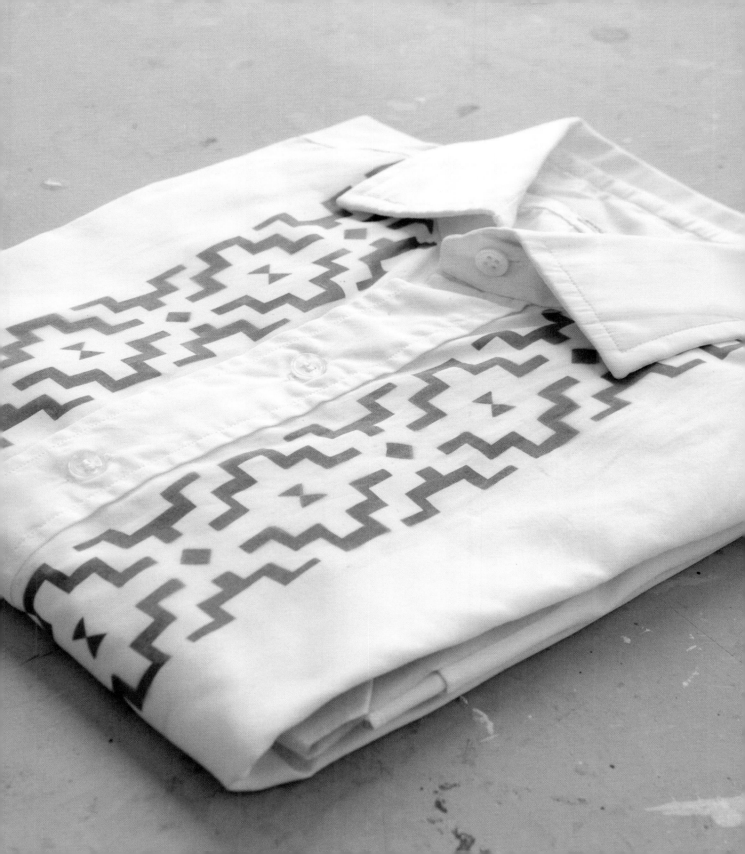

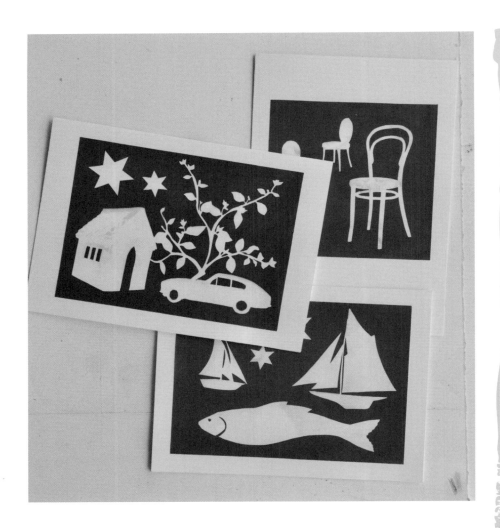

TROUBLESHOOTING

- The text or images from the reverse side of the magazine cut-outs might appear in your artwork, depending on the thickness of the page it came from and the exposure time. The cut-outs can be backed with paper to prevent this happening but I personally like it and think it adds interest to the print.

- If marks appear on the prints that shouldn't be there, the glass may be dirty. Make sure the glass is clean and there are no specs of dust or smudges.

GREETINGS CARDS

All sorts of found objects from the home and garden can be used for sun printing. This project uses images cut from magazines to produce interesting prints on homemade greetings cards.

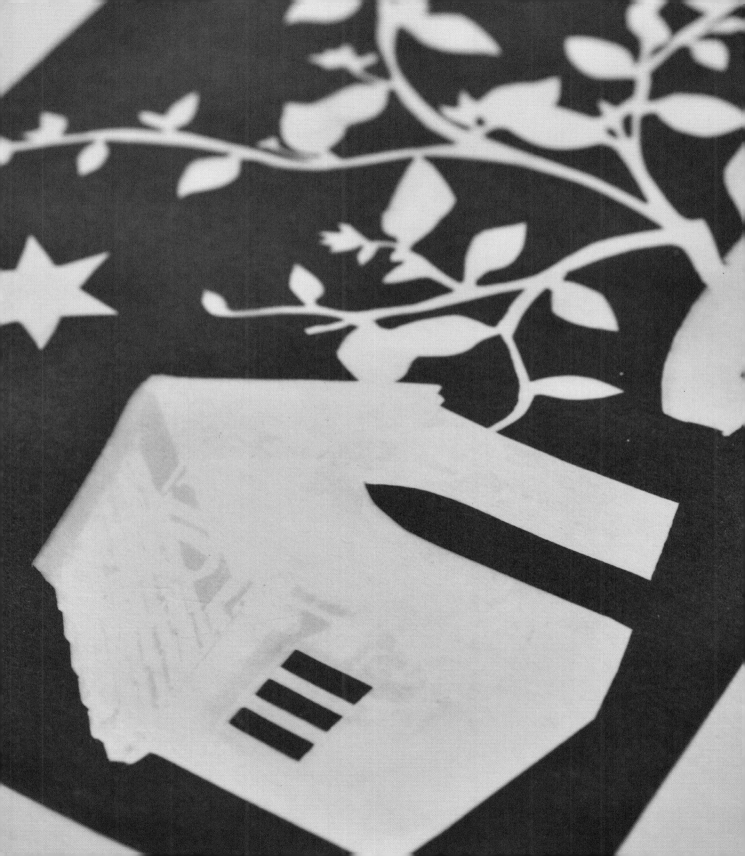

INSTRUCTIONS
CUTTING THE STENCILS
1: Cut images from magazines using a sharp craft knife on a cutting mat. Turn the cut-outs over to see how they look from the back, without the printed details, as it will be just the cut shape that will appear on the exposed paper (see Troubleshooting, page 122). Extra detail can be added by cutting more from the basic shape of the cut-outs.

PRINTING THE SHAPES
2: Keep the paper out of the light until you are ready to print. Lay a piece of black paper on top of the board. This is to prevent the sunlight refracting onto the back of the treated paper. Put the cyanotype paper on top, with the treated side face up.

3: Place the magazine cut-outs in position on the paper. It is a good idea to roughly work out the composition before removing the paper from the protective packaging.

Black paper
Cyanotype paper
Board

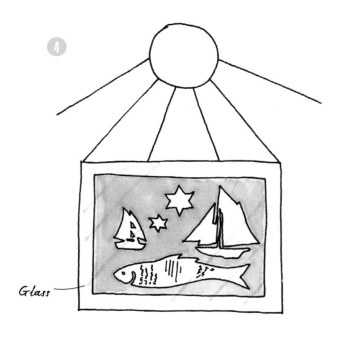

Glass

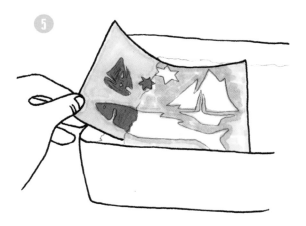

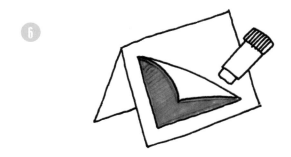

EXPOSURE

4: Follow the manufacturer's instructions for the cyanotype paper exposure times. Place the glass on top of the cut-outs (see Troubleshooting, page 122) and expose it to the sunlight for the required time. The exposed cyanotype paper will fade or change in colour.

5: Keeping the cyanotype paper out of the sunlight, remove the cut-outs. Rinse the paper in a container of water, according to the manufacturer's instructions. The unexposed paper will turn white. Leave to dry flat. The blue will deepen and the images will sharpen as the paper dries.

MOUNTING

6: If necessary, trim the printed paper, and glue the artwork to the blank cards.

PHOTO NEGATIVE

Turn photographs of favourite landmarks or holiday destinations into beautiful cyanotype prints to send as postcards to loved ones or to use to decorate a box to hold keepsakes or gifts.

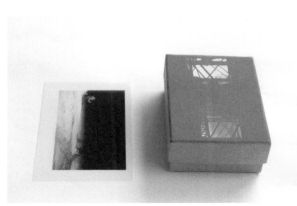

TOOLS AND MATERIALS

- Protective gloves, apron and goggles
- Cyanotype sensitizer solution
- Acid-free paper
- Paintbrush
- Black paper (larger than the negative)
- Board (larger than the negative)
- Non-UV protected glass (larger than the negative)
- Negative transparency in actual size of finished print
- Container for citric acid bath
- Citric acid
- Measuring jug
- Scissors
- Glue stick or spray mount
- Stiff paper, postcard or gift box to fit the finished image

TROUBLESHOOTING

- If after the sensitizer has dried, the colour of the paper has changed to green or blue, it means there are impurities in the paper. This will affect the cyanotype print.
- Ensure the glass is clean and dust-free, as this can cause specks to appear in the finished print.
- If the image is very pale and washed-out after developing, it may be underexposed or you may not have applied enough cyanotype sensitizer to the paper. Make sure the solution has a thick, even coat. A second coat can be applied if the first has dried looking pale and patchy. When exposing the print, the colour of the solution will change.

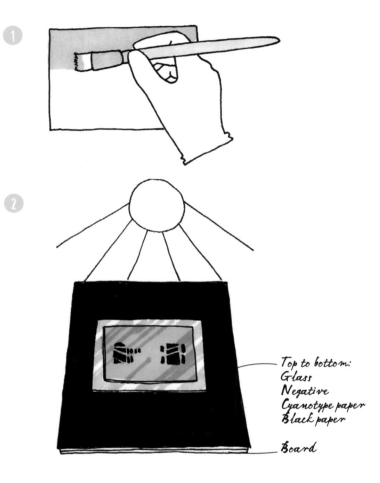

Top to bottom:
Glass
Negative
Cyanotype paper
Black paper

Board

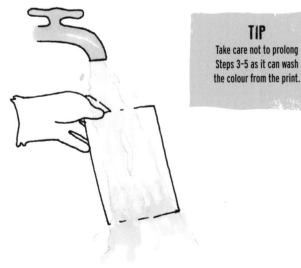

TIP
Take care not to prolong
Steps 3-5 as it can wash
the colour from the print.

INSTRUCTIONS
PREPARE THE PAPER

1: Wearing the protective apron, gloves and eyewear, apply an even coating of cyanotype sensitizer to the acid-free paper in a darkened room with a paintbrush. Allow to dry completely in the dark. The coating on the paper should be a yellow colour. If the colour changes to green or blue, this indicates there are impurities in the paper that have affected the sensitizer. This paper should be discarded, as it will affect the cyanotype print causing fogging, meaning lighter areas will be blurred and discoloured.

2: In a darkened room, lay the black paper on top of the board and place the dry, coated acid-free paper on top of the black paper. Place the transparency on the paper with the printed side facing up, as the sensitizer can cause damage to the negative. Lay the non-UV protected glass on top of the negative and expose to the sun. Refer to the manufacturer's instructions for exposure times. This can vary according to the strength of the sunlight and will need longer if it is not a bright day. The exposed areas of the paper will change colour.

DEVELOPING

3: Wash the paper in running water for around three minutes or according to the manufacturer's instructions. The colour will run from the unexposed areas, revealing the white paper.

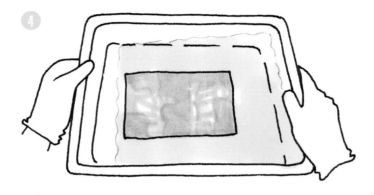

4: In the container, dissolve the citric acid in water, according to the manufacturer's instructions. I used ³/₄ oz (20g) of citric acid to 1pt (0.5l) water. Immerse the paper in the citric acid bath and agitate constantly for around two minutes. This helps clear the print, resulting in better contrast. Check there is no yellow left in the paper. If so, return it to the citric acid bath for a little longer.

5: Finally rinse once more under running water, this time for around five minutes or according to the manufacturer's instructions. Leave the print to dry flat. The image will appear pale at first, but as the paper dries, the colour will deepen to a beautiful Prussian blue and the white in the print will sharpen. (See Troubleshooting, page 127.)

MOUNTING THE PRINTS

6: Trim the finished print, if necessary, and glue it to stiff paper or a blank postcard. Alternatively, the print can decorate the lid of a gift box.

SOLAR PLATE

Solar plate is a metal sheet coated with a photosensitive polymer layer that hardens when exposed to UV light. Any areas that have not been exposed, wash away in water to reveal the image. A second exposure hardens the surface, and the plate is ready to print.

TEMPLATE

TOOLS AND MATERIALS
- Ruler
- Acetate
- Masking tape
- India ink
- Fine and medium paintbrushes
- A5 solar plate
- Utility knife or paper cutter
- Board, larger than the negative
- Black paper, larger than the negative
- Non-UV protected glass, larger than the negative
- Metal file (optional)
- Card (such as a piece of mount board)
- Protective gloves, apron and goggles
- Shallow container
- Newsprint
- Soft paintbrush or mushroom brush
- Oil-based block-printing ink
- Paint palette
- Rubber paint brayer
- Paper
- Baren or wooden spoon
- Soft brush, such as shoe-polish brush or sponge
- Vegetable or baby oil
- Talcum powder (optional)

TROUBLESHOOTING
- If everything washed away when developing the plate, there was not enough exposure; if not enough washed away, the plate may have been over-exposed, or it needs more washing.
- If the polymer ripples and lifts at the edges of the image, the plate has been washed for too long.
- If the ink transfers from the acetate to the plate, dust both with talcum powder then smooth over with a soft brush.

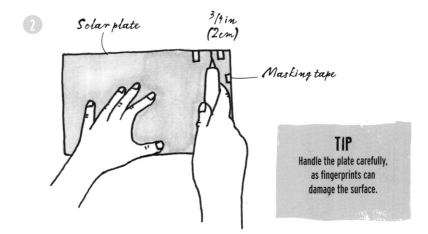

INSTRUCTIONS

PREPARING THE ACETATE

1: Enlarge the template on page 133 or use your own artwork. Lay the acetate over the template and tape it in place with masking tape. Carefully trace the design onto the acetate with India ink and the paintbrushes. When the ink has dried on the acetate, hold it up to a window to see if the light shows through the image. It may need two or three coats of ink to make it lightfast.

TEST STRIP

2: Read the manufacturer's instructions on the solar plate. Handle the plate carefully, as fingerprints can damage the surface. To determine the amount of time the solar plate needs to be exposed, it is a good idea to do a test strip, rather than to guess how long it will take and potentially waste a solar plate. There is no indication on the surface of the plate as with cyanotype printing, which changes colour as exposure takes place. Working in a dimly lit room, attach the plate's protective film to the end of the plate with small pieces of masking tape. Use a utility knife or paper cutter to cut a ³⁄₄in (2cm) wide strip from the short end of the solar plate. You will need to score it a few times before it comes away.

3: Lay the black paper on the board and the solar plate strip on top. Position the acetate, with the ink-side facing down, so that both painted and transparent areas of the design cover the whole of the strip.

Solar plate

³⁄₄in (2cm)

Masking tape

TIP
Handle the plate carefully, as fingerprints can damage the surface.

Solar plate strip

Acetate

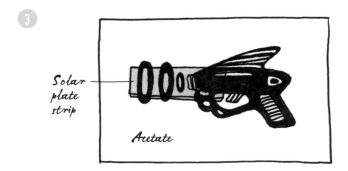

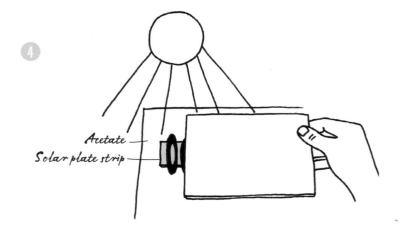

Acetate

Solar plate strip

4: Hold a piece of card over the strip, around ³⁄₄in (2cm) from the top edge and expose to the light for around one minute before moving the card another ³⁄₄in (2cm) down, exposing it for a further minute. Continue the process until you get to the end of the strip. The area of the test strip that you uncovered first will have had the longest exposure time. Follow Step 7 overleaf to develop the test strip.

EXPOSING THE SOLAR PLATE

5: Refer to the test strip for the correct exposure time for the solar plate. A lip often occurs at the edge of the plate. This is caused when it was cut to size and can be removed with a utility knife or paper cutter. Alternatively, it can be carefully filed down.

6: Remove the protective film from the solar plate. The surface of the plate can be lightly dusted with talcum powder to prevent the ink on the acetate sticking. Place the solar plate, polymer-side up, on the black paper covering the board. Lay the acetate, ink-side facing down, on the plate and place the glass on top. It is important that the glass is clean and dust free. Expose the solar plate.

Top to bottom:
Glass
Acetate
Solar plate
Black paper

Board

DEVELOPING THE SOLAR PLATE

7: Wear protective gloves, apron and goggles when developing the solar plate and make sure the room is well ventilated. Fill a shallow container with a small amount of room-temperature water and submerge the plate. Holding the plate, use a soft brush to gently rub its surface and the unexposed polymer will begin to lift away. I dipped the brush and plate into the water several times when doing this. The image will appear in reverse. It will take around five minutes to wash away the entire polymer that covered the image, revealing the metal plate (see Troubleshooting, page 133). Revealing the metal is important for relief print making.

8: Blot immediately with newsprint, taking care not to damage the remaining polymer because it is still delicate.

HARDENING THE EXPOSED PLATE

9: Expose the solar plate once more by placing it in the sun for the same amount or longer than the exposure time, until the surface of the plate no longer feels sticky to the touch.

TIP
Be careful when blotting the plate in step 8, only using two or three sheets of newsprint. Do not use the same sheet twice.

Newsprint

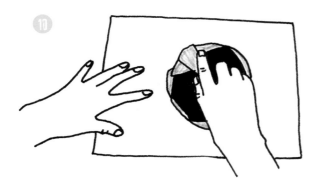

PRINTING

10: Squeeze the ink onto the palette and roll the brayer through it until it is evenly coated. Roll a layer of ink over the surface of the plate. Lay the paper over the plate and burnish with a baren or the back of a wooden spoon. Lift the corner of the paper to check the print and if it needs a little more burnishing. Lift the paper from the plate and leave to dry.

CLEANING UP

11: The plate can be cleaned with water and a soft shoe polish brush or sponge and left to air dry. Apply a thin film of vegetable or baby oil to protect the surface.

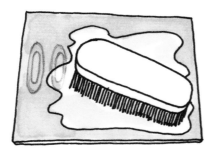

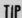

TIP
Store the solar plate in the plastic light-resistant bag in which it came. Exposure to light over time will continue to harden the plate and make it brittle.

IMAGE TRANSFER AND STENCILS

A stencil is a template that can be used to repeat a pattern or design. The shape that is cut out is the positive and the empty space left behind is the negative. Either can be used to produce different results. With the stencil in place, the pigment is applied and, when the stencil is removed, the image is left on the surface.

In the prehistoric era, people would use their hand as a stencil by placing it against the wall of a cave and blowing particles of pigment around it. This technique produced an image of the outline of their hand. Examples can be found in Paleolithic caves in France and Spain.

Around 200 years after the invention of paper in China in the second century AD, the first paper-cut stencils were developed. In Japan, designs were cut into a material made from several sheets of mulberry paper, which had been overlaid and pressed together. These were used to decorate textiles. For kimono printing, negative areas of the stencils were cut away and the floating shapes were attached to the main structure using human hair and, in later years, fine silk. When the pigment was applied over the stencil, any lines of the silk threads left after removing it were barely visible.

In the early 1940s, Henri Matisse (1869–1954) cut shapes from painted paper. His book, *Jazz*, was published in 1947 and featured works that were produced by brushing gouache through stencils that had been hand-cut from thin sheets of metal. Contemporary artists, such as Banksy, create strong, visual images with the use of stencils.

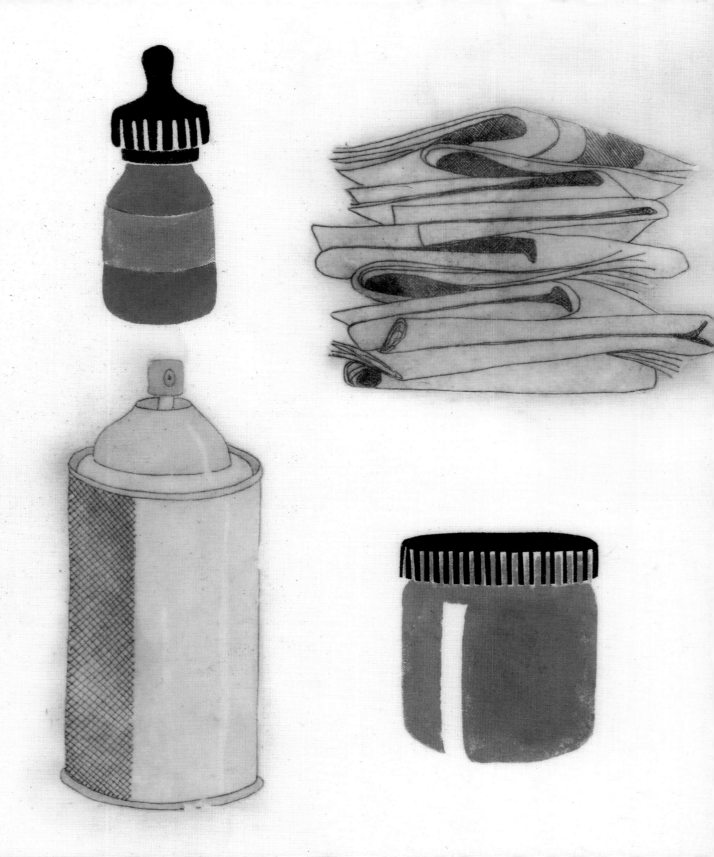

TOOLS AND MATERIALS

SOFT SPONGE

When transferring an image from a magazine to fabric using acrylic gel medium, the paper from the printed page is removed by gently rubbing the surface with the tips of your fingers. This can take quite a while and after you have made a start you can rest your fingertips and use a small, soft sponge instead. Use a cosmetic sponge or a dish sponge cut down to a small size with the scouring pad removed. These small sponges are also useful for wiping away small areas of ink or residual gel medium.

SHRINKABLE PLASTIC

This comes in a range of plain colours or transparent, ready to draw or stamp your own design. It is also available as ready patterned and some are suitable for inkjet printing. The colour that is applied in the design will become more intense after the plastic has been heated and shrunk in the oven.

FREEZER PAPER

This is a paper coated with plastic on one side. Generally used to preserve food, it is ideal for stencils. When ironed to the fabric it adheres lightly and can be removed easily after use.

INKS

Fabric paint is used in this chapter but acrylic paint can be used when mixed with textile medium. Refer to the manufacturer's instructions for the ratio of paint to medium. The inkpad and markers used for the Shrinkable Plastic project on page 147 must be permanent as they will smudge to the touch, even after baking. Just be careful not to get it on your clothing.

ACRYLIC GEL MEDIUM

This is a transparent gel that can be mixed with acrylic colour to increase the viscosity and transparency, slow down the drying time and add texture. It can also be used to stick down collage materials.

UV-RESISTANT VARNISH

A varnish with UV filters is ideal to use for protecting projects that in time will fade. Look for an archival varnish as this prevents yellowing which also occurs with age. It can be applied with a paintbrush or sprayed.

MAGAZINES AND NEWSPAPERS

I like to keep interesting pictures and cuttings I find in magazines and newspapers. As well as being a source of inspiration, these will provide you with many possibilities for decorating your projects using the image transfer method (see Cushion Cover, page 142 and Mirror, page 153). Bear in mind that the image will appear in reverse; this is especially important if you wish to use text.

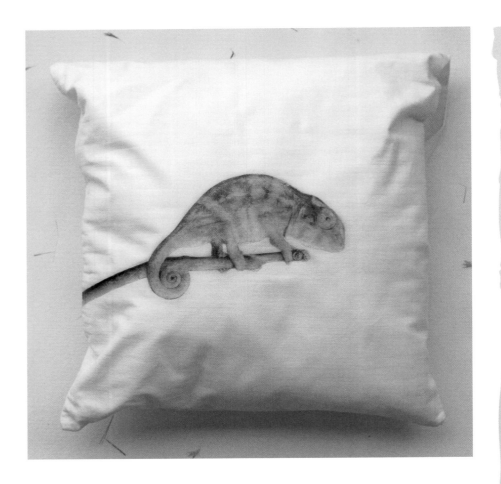

TROUBLESHOOTING

- If parts of the transfer have been rubbed away, you are being too vigorous. You need to remove the paper gently. This can take a while – some of the paper will come away easily, while other areas are likely to be more stubborn. Patience is the key.
- The transferred image will be a faded version of the original but can be brightened up a little by applying a thin coat of gel medium.
- If the cushion cover needs laundering, wash by hand with care. Use a cool iron on the reverse side.

CUSHION COVER

Give a cushion cover a twist by applying a transfer using a magazine or newspaper cutting. The paper is peeled away from the fabric to magically reveal your chosen image.

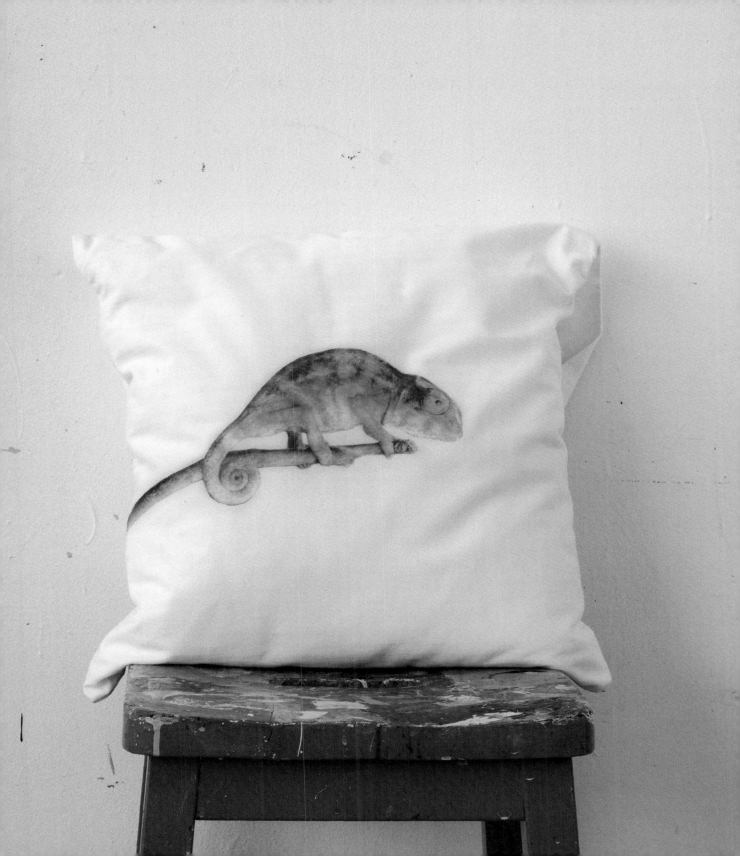

INSTRUCTIONS
PREPARING THE IMAGES

1: Insert a plastic carrier bag into the cushion cover, adjusting it so that it lies flat. This is to prevent the gel medium penetrating through the fabric and sticking the front and back of the cover together. Smooth the front of the cover down.

2: Choose an image from a magazine or newspaper, considering that it will appear in reverse on the cushion cover, and cut out with scissors.

3: Brush an even coating of the gel medium over the front of the image.

> ## TIP
> Coat every bit of the image with the gel medium so the entire image adheres to the fabric.

4

5

Water

6

Cushion pad

TRANSFERRING THE IMAGE

4: Lay the image, with the coated side facing down, in place on the front of the cushion cover. Smooth out any air bubbles and wipe away excess gel medium with a paper towel. Leave it to dry completely, preferably overnight.

5: Using the spray bottle, wet the back of the magazine or newspaper cutting. Leave for a couple of minutes to soak through. Starting at the centre of the cutting and working towards the edges, rub away the cutting with your fingers to remove the paper; this will take some time (see Troubleshooting, page 142). A soft sponge can be used to help remove the paper. You will soon see your chosen image emerging as the paper comes away.

6: When the whole of the chosen image is uncovered, brush away the paper with your hand and leave the transfer to dry naturally. The result will be faded and translucent, compared to the original image, allowing any pattern on the fabric to show through (see Troubleshooting, page 142). Remove the bag from inside the cover and pop in a cushion pad.

> **TIP**
> After removing the paper from the image, the transfer will look a bit chalky until it has dried completely.

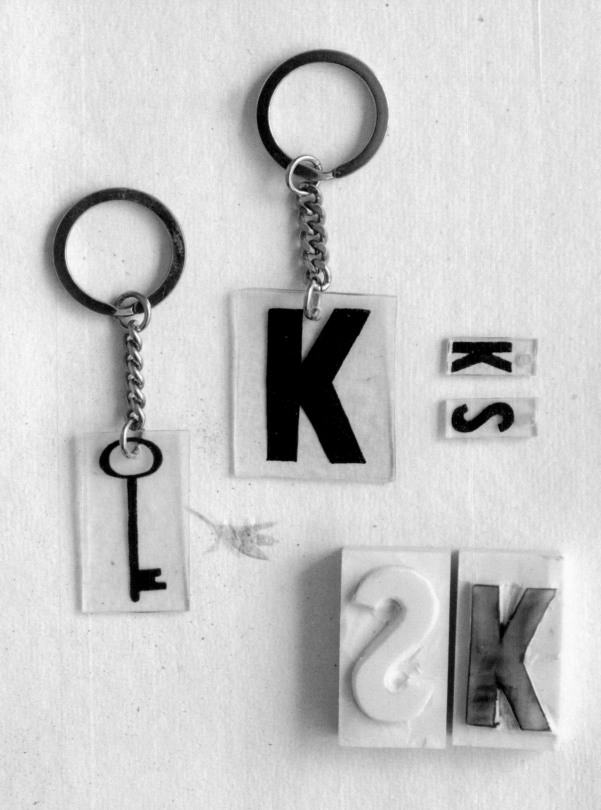

SHRINKABLE PLASTIC

This project brings back childhood memories of baking a crisp packet in the oven and the excitement of watching it curl and shrink as it heats through. Here, however, you use shrinkable plastic to create striking printed jewellery and keyrings.

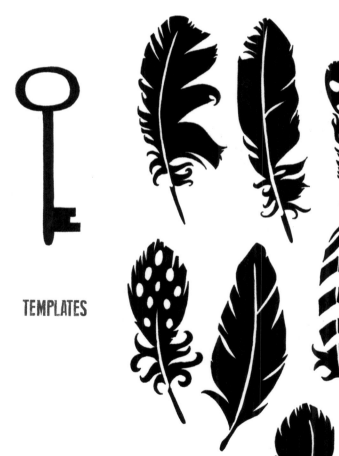

TEMPLATES

- Soft pencil
- Tracing paper
- Vinyl eraser stamps
- Lino-cutting tools
- Permanent inkpad
- Shrinkable clear plastic
- Permanent markers
- Cutting board
- Sharp scissors
- Hole punch
- Baking tray
- Tin foil or greaseproof paper
- Oven gloves
- 2 pairs of jewellery pliers
- Chain necklace
- Jump ring for each pendant
- Pair of ear wires
- Keyring

TROUBLESHOOTING

- If you wish to print a size larger than the vinyl eraser, carve the image into lino then cut the lino to make a bigger stamp.

- Don't worry if the traced design looks pale; it will darken as it shrinks.

- Depending on the size of your pendants, it may be a good idea to bake just one or two at a time to prevent them sticking together.

- As the plastic shrinks it will twist and turn in the oven. To prevent it sticking to itself, add a wider border at each side and punch the hole closer to or into the image. It can take a few attempts to get it right, so cut some extra pendants to allow for errors.

Tracing paper

Ink pad

Shrinkable plastic

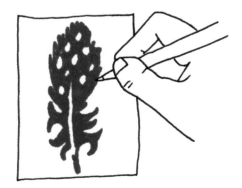

INSTRUCTIONS

STAMPING THE DESIGN

1: The alphabet eraser stamps (see page 39) can be used to make personalized pendants. Alternatively, you could make earrings or a necklace with the feather templates or a keyring with the key template by reducing the templates on page 147 and transferring the images to an eraser (see Troubleshooting, page 147). Using a soft pencil, trace the design onto tracing paper. Turn the tracing paper over and place on an eraser, lining it up so it is central. Rub the back of the tracing paper with a finger to transfer the letter or image on to the surface of the eraser. The letter will appear in reverse. Carve away the areas in white on the template using the lino-cutting tools.

2: Press the stamp into the permanent inkpad, check it is coated evenly and press it firmly onto the plastic. Leave space around each design if printing multiple images on one sheet. Allow the ink to dry completely.

TRACING THE DESIGN

3: If, instead of stamping the design, you choose to trace the template, first check the manufacturer's instructions to see how much shrinkage will occur then enlarge or reduce the artwork to the required size. Using the permanent marker pen, trace the chosen image onto the shrinkable plastic and allow it to dry completely.

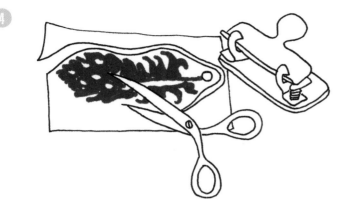

CUTTING THE DESIGN

4: Cut around the individual designs with sharp scissors, leaving a narrow border around each of the pendants. Leave a wider border if making the keyring. Punch a hole at one end of the image to link to a chain or ear wire.

SHRINKING THE PLASTIC

5: Following the manufacturer's instructions, pre-heat the oven to the required temperature. Place the plastic on a baking tray lined with foil or greaseproof paper to prevent it sticking. (See Troubleshooting, page 147.) Check on your plastic designs as they bake. As they shrink you will see them curl up and then flatten. Put on the oven gloves and remove the plastic pendants from the oven. Leave to cool.

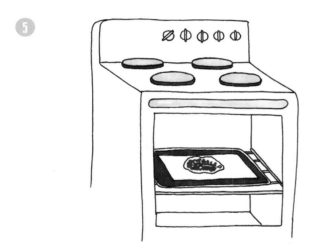

MAKING THE JEWELLERY

6: Open up a jump ring by gripping each end with a pair of pliers and easing the wire apart. Thread through the hole in the pendant. Thread the jump ring onto the chain necklace and, holding the wire with one pair of pliers, use the other pair to close the jump ring. Leave as a single pendant or hang several from one chain. To make a pair of earrings, use the pliers to open up the ring at the end of the ear wire, thread it through the hole in the pendant and close with the pliers. For the keyring, open up the jump ring at the end of the chain and thread through the hold in the printed plastic. Close the ring using the pliers as before.

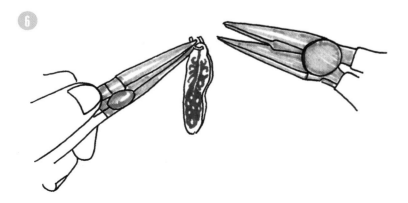

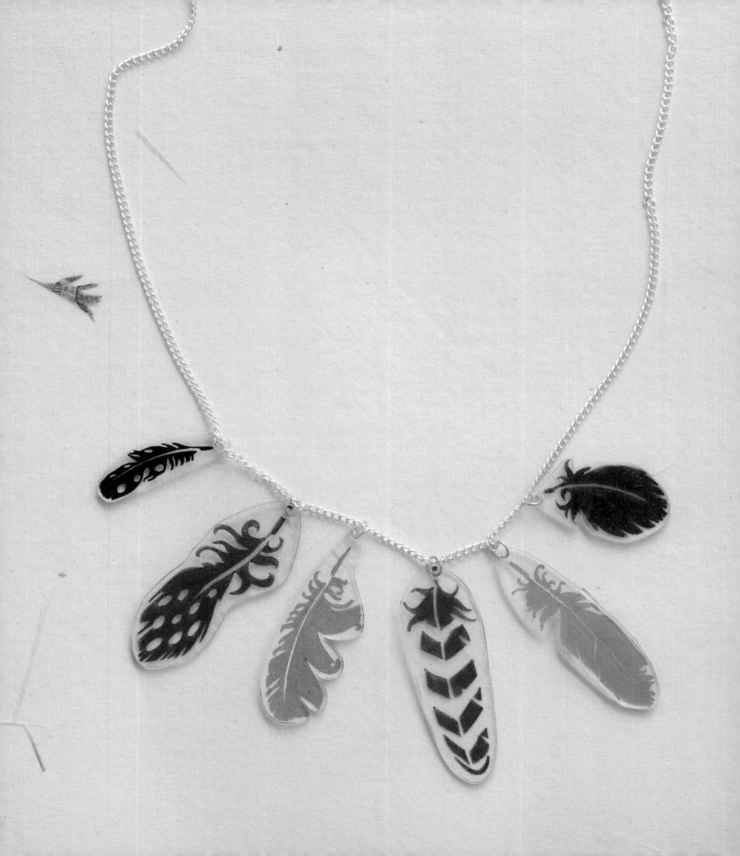

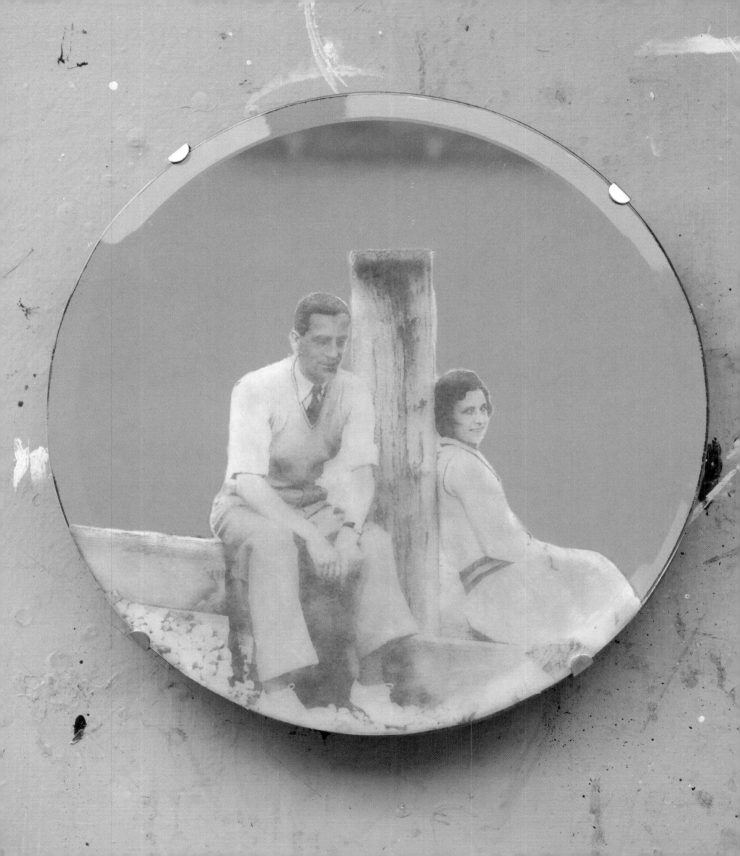

MIRROR

An alternative way to display an old family
photograph is to use it to decorate the
surface of a mirror. Choose an image
with plenty of light areas, as the mirror will
shine through those parts of the transfer.

TROUBLESHOOTING

- It is best to remove air bubbles when you first place the gel medium-coated image onto the mirror. If you notice one you missed as you rub the paper away, stop and allow it to dry. Use a paintbrush to insert some gel medium into the bubble if it occurs at the edge of the image. If it is in the middle, use a craft knife to make a small cut in the paper and use the paintbrush to push the gel medium through the opening. Smooth the paper down and leave to dry before continuing.

- If a small part of the image comes away as you rub, finish removing all the paper and leave to dry before gluing the section back in place with the gel medium. It is a good idea to print a second copy of your photo in case the section cannot be re-used.

- You will find that tiny fibres are left behind when the transfer has dried. The process of wetting and rubbing away the paper needs to be repeated a few times, leaving it to dry in between.

- Even though the transfer appears clear when it is still wet, there will inevitably be a papery film left over the photo at the end. Use a coat of varnish to help bring the image through clearly again.

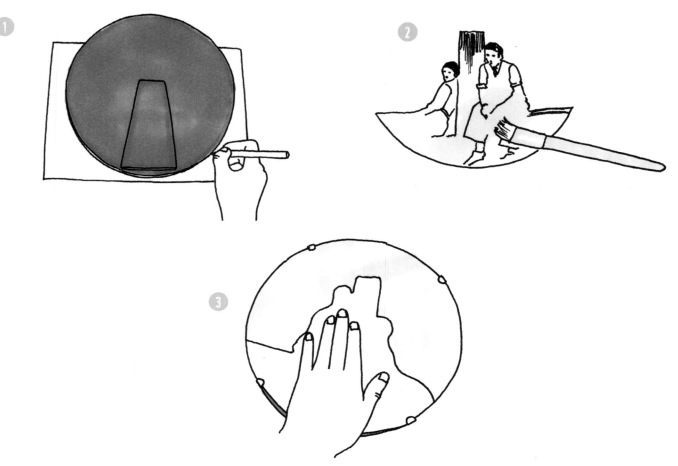

INSTRUCTIONS
CHOOSE THE PHOTO

1: When choosing an image for the mirror, think about the amount of surface it will cover. A photo that has plenty of light areas is ideal since the mirror will show through these. Remember that the image will appear in reverse when transferred to the mirror. Cut the photocopy to fit the shape of the mirror and trim away any excess that is not required.

PREPARING TO PRINT

2: Make sure that the mirror is clean before starting. Brush an even coating of the gel medium over the front of the image.

3: With the coated side facing down, lay the image onto the surface of the mirror and smooth out any air bubbles and creases (see Troubleshooting, page 153). Wipe away excess gel medium with a paper towel and leave overnight to dry.

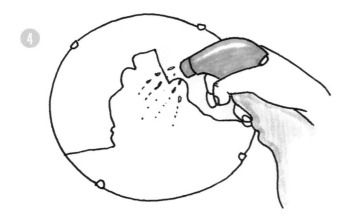

4: When the photocopy is completely dry, wet the back of it using the spray bottle filled with water and let it soak through the paper. (See Troubleshooting, page 153.)

PRINTING

5: Use your fingers to gently rub the centre of the photocopy. The paper will begin to come away. Take care not to rub the transferred image away (see Troubleshooting, page 153). The transferred image will begin to emerge as the paper is removed and the mirror shines through. Continue spraying water and rubbing the photocopy very carefully until the excess paper has been removed.

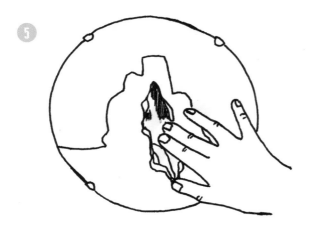

6: Leave the transfer to dry (see Troubleshooting, page 153). Once dry, apply the varnish carefully with a paintbrush. Make sure to avoid getting varnish on the exposed mirror.

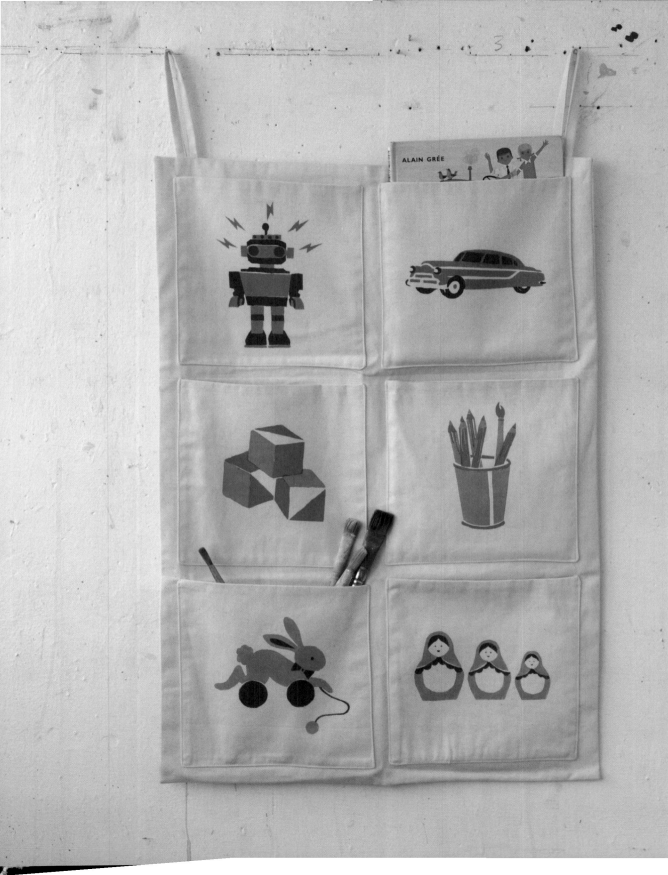

WALL TIDY

This cute wall tidy is decorated with simple but fun stencilled designs, and is perfect for storing children's small toys. It would also make a great beauty product tidy - just alter the designs.

FIRST COLOUR

SECOND COLOUR

TEMPLATES

TOOLS AND MATERIALS

- 6 pieces of medium-weight cotton fabric, 10 x 10in (26 x 26cm), for pocket fronts
- 6 pieces of light-weight cotton or polyester cotton mix fabric, 10 x 10in (26 x 26cm), for pocket linings
- 2 pieces of medium-weight cotton fabric, 22½ x 33in (57 x 83cm), for the back
- 1 strip of cotton fabric, 2 x 24in (5 x 60cm) for the loops
- Freezer paper
- Masking tape
- Craft knife
- Cutting mat
- Pencil
- Scissors (paper and fabric)
- Iron
- Newsprint or brown paper
- Water-based fabric ink or paint in 3 colours of your choice
- Small sponge
- Paintbrush
- Card (such as a postcard)
- Dry cloth
- Thread to match fabric
- Sewing machine or needle
- Fabric scissors
- Dressmaker's pins

TROUBLESHOOTING

- Make sure the brush or sponge is dry before use and that they are charged with just a small amount of ink.
- If the colour bleeds around the edges you may be pushing the ink under the stencil.
- Be especially careful when working near the cut areas.

TEMPLATES CONTINUED

FIRST COLOUR

SECOND COLOUR

FIRST COLOUR

SECOND COLOUR

FIRST COLOUR

SECOND COLOUR

FIRST COLOUR

SECOND COLOUR

FIRST COLOUR

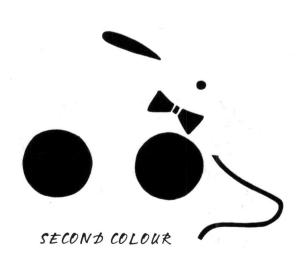

SECOND COLOUR

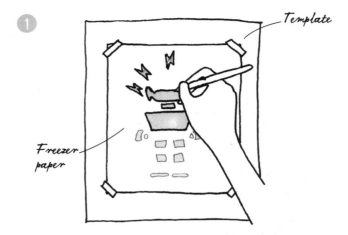

Template

Freezer paper

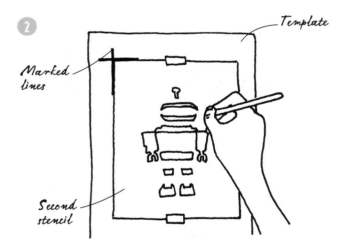

Template

Marked lines

Second stencil

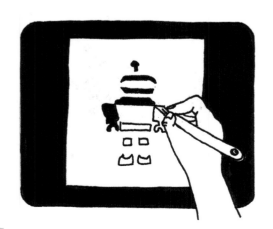

INSTRUCTIONS
CUTTING THE STENCILS

1: Enlarge the templates on pages 157-9 to fit the fabric pockets or use your own artwork. The robot is the largest motif and I made it around 8in (20cm) tall, including the electric bolt. Cut two identical pieces from the freezer paper for each stencil, allowing a border of at least 1in (2.5cm) all round the image. Use masking tape to stick the freezer paper (with the paper side facing up) onto the artwork to stop it moving. Trace the first colourway of the design.

2: Align the first traced stencil over the template for the second colour. Mark lines on the template along the top left-hand corner of the stencil; this allows the next piece of freezer paper to be lined up in the same position as the first and will assist with correct registration when printing.

3: Carefully cut away the areas of all the stencils that are in black on the templates, using a sharp craft knife on a cutting mat.

TIP
It is advisable to wash and iron the fabric before printing onto it.

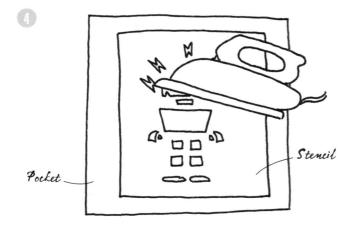

4

Pocket

Stencil

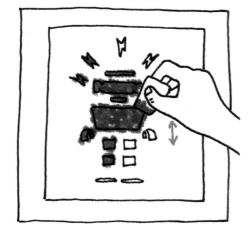

5

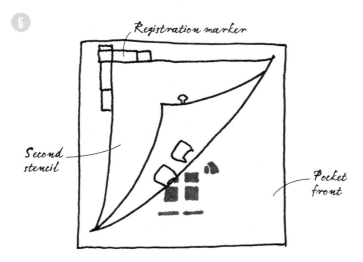

6

Registration marker

Second stencil

Pocket front

PRINTING

4: Start with the lightest colour first. Lay the freezer paper stencil with the plastic side facing down onto the pocket front piece and fix the stencil in place with a hot iron. Use the tip of the iron around the edges of the areas that are cut away, making sure the stencil has properly adhered to the fabric.

5: Move the pocket front from the ironing board to a work surface for printing. Since the ink will go through the fabric a little, it is a good idea to protect the surface with a sheet of newsprint or brown paper. Apply the ink a little at a time with the sponge (see Troubleshooting, page 157), dabbing the fabric to build up the colour. Take care not to push the ink under the edges of the stencil. Use the paintbrush for smaller areas.

6: Cut two rectangles from the card and stick them to the top left-hand corner of the fabric, butting the straight edges right up against the freezer paper. This will be used to register the next colour correctly. Remove the freezer paper when the ink has completely dried. Lay the second stencil, plastic side down, on the fabric so the top left-hand corner is right against the registration markers. Iron it in place and apply the second colour as before. Leave to dry.

MAKING THE WALL TIDY

7: Once the ink has dried, the stencil can be removed. Lay a dry cloth over the fabric and fix the ink by ironing well for a few minutes on both sides at the highest heat suitable.

8: Join the printed pocket fronts to the linings by pinning them with right sides together. Stitch around the pocket, ³⁄₈in (1cm) from the edge, leaving an opening at the lower edge of approximately 4in (10cm). Cut diagonally across the corners to reduce fabric bulk, taking care not to cut the stitches. Turn right side out and press with an iron. Repeat for the remaining five pockets.

9: Pin each pocket with the printed side facing out to the right side of one of the large pieces of fabric. Position the pockets 1³⁄₈in (3.5cm) from the outside edges of the backing fabric and at ³⁄₄in (2cm) intervals from each other. Make sure the open edges of the pockets are pinned together. Stitch close to the side and lower edges of each pocket. This will close the opening at the lower edge of the pockets as well as securing them to the backing fabric.

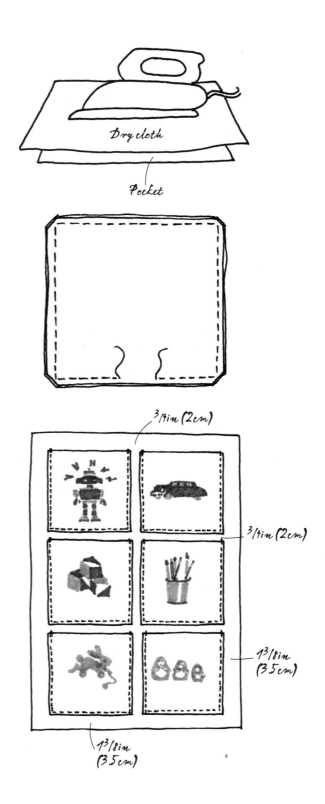

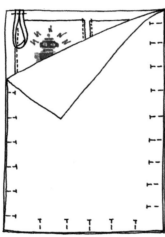

10: To make the loops, fold the two long edges into the centre with wrong sides together and press with an iron. Fold in half lengthways; press and stitch close to the edge. Cut the piece in half to make two loops.

11: Fold each piece in half widthways and align the raw edges of the loops with the edge of the top of the fabric. Sew in place. With right sides together, pin the large pieces of fabric so the pockets and loops are sandwiched between them.

12: Sew all around, 3/8in (1cm) in from the raw edges, leaving an opening in the lower edge of around 8in (20cm). Cut diagonally across the corners to reduce fabric bulk, taking care not to cut the stitches. Turn right side out, stitch the opening by hand or machine and press with an iron.

8in (20cm)

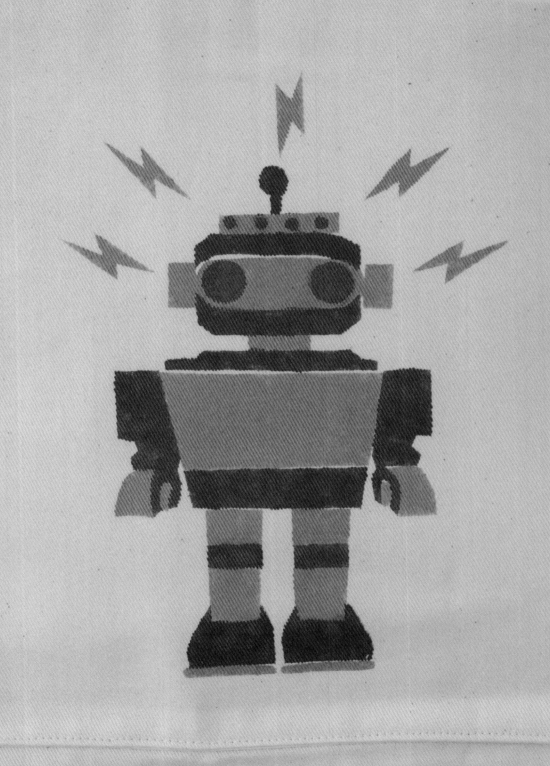

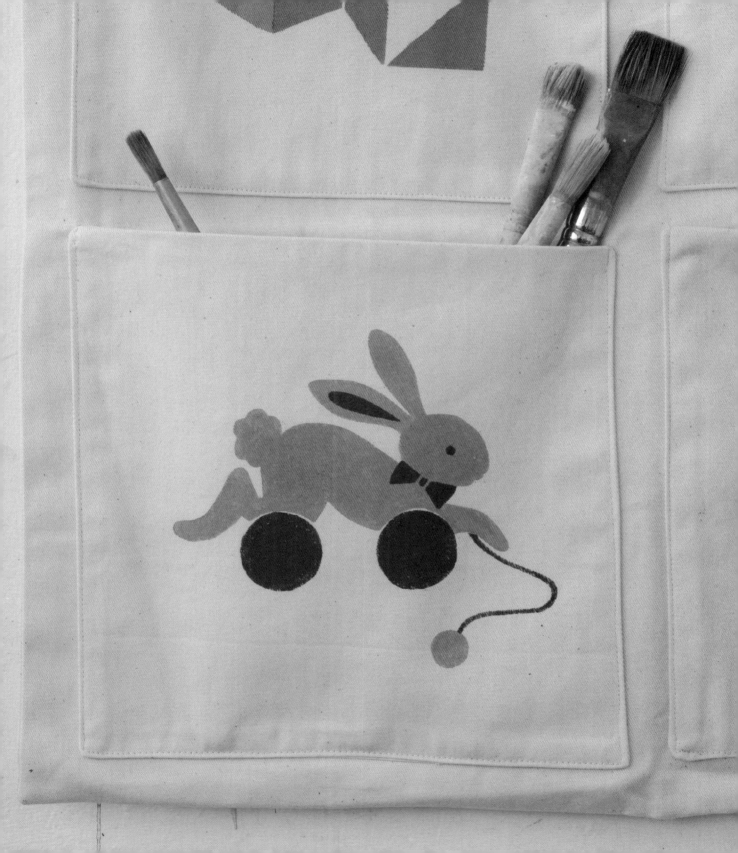

T-SHIRT

This striking motorbike design is broken down into three colours, each of which uses a separate stencil. These are cut, overlaid and printed one at a time, to produce the finished T-shirt logo.

TOOLS AND MATERIALS

- Freezer paper
- Scissors
- Pencil
- Craft knife
- Cutting mat
- Tracing paper
- Plain T-shirt, washed and ironed
- Chipboard or stiff cardboard to fit inside the T-shirt
- Masking tape
- Iron
- Black, grey and red water-based fabric ink or paint
- Paintbrush
- Dry cloth

TROUBLESHOOTING

- If you find that the colour bleeds under the stencil, you may have overloaded your brush with ink. To prevent this, use just a little colour at a time and dab the brush rather than push the colour around with it.

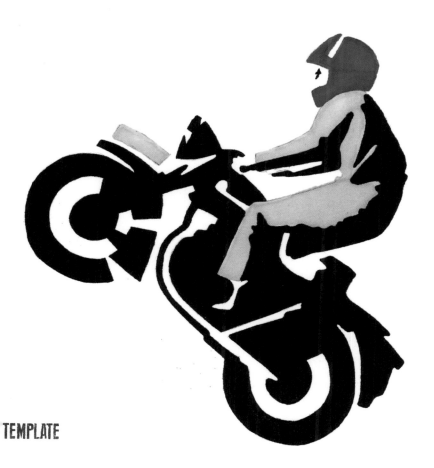

TEMPLATE

RED

BLACK GREY

Separate piece taped to stencil for safe keeping

Masking tape

Tracing paper

Chip board

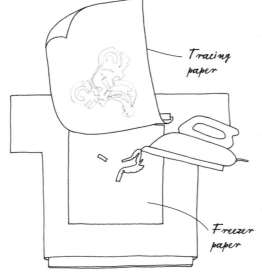

Tracing paper

Freezer paper

INSTRUCTIONS
CUTTING THE STENCILS

1: Enlarge or reduce the motorbike template on page 167 to fit your fabric, or use your own artwork. Cut three identical sheets of the freezer paper to approximately 2in (5cm) larger all-round than the image. With the paper side facing up, trace each colourway of the design onto a piece of freezer paper. Using a sharp craft knife on a cutting mat, carefully cut away the coloured areas of the template design from the freezer paper. You will have three separate stencils. The white area coming from the back wheel is a separate piece that should be kept with the main stencil until it is needed.

2: Trace the image onto the tracing paper allowing ⅝in (1.5cm) more at the top edge than the freezer paper. This will be used to help position the stencil. Insert the piece of chipboard or card inside the T-shirt. This will stop the ink or paint seeping through to the back and should not be removed until all three colours have dried completely. Lay the tracing paper onto the T-shirt. When you are happy with the position of the image, stick the tracing paper down only at the top edge with two or three pieces of masking tape.

3: As a general rule, if the design requires the colours to be overlapped, print the lightest first. In this case, it doesn't really matter because the colours are separate, but I still began with lightest, which is the grey. Slip the freezer paper stencil of the first colour to be printed, plastic side facing down, between the

tracing paper and the front of the T-shirt. When the area that is cut away is in line with the traced image, lift the tracing paper back and fix the freezer paper in place onto the T-shirt with a hot iron. Concentrate particularly around the edges of the areas that are cut away, using the tip of the iron, to ensure the stencil has adhered to the fabric.

PRINTING

4: Using the paintbrush, dab the ink through the cut-away area onto the T-shirt. Use a very small amount of the ink, building up the colour by recharging the brush with a little ink at a time (see Troubleshooting, page 167). Take care not to push the colour under the edges of the stencil. Leave the freezer paper in place until the ink is completely dry.

5: When the first colour has dried, the freezer paper can be lifted off. Repeat the process for the second stencil, the motorcyclist's helmet. Fill in the cut area in red and leave to dry. The third stencil is the most complex with the extra little piece that has been cut from the freezer paper. Iron the larger template in place first before positioning and fixing the small piece onto the T-shirt.

FIXING THE PRINT

6: Once the fabric has dried, the final stencil can be lifted off the T-shirt and the chipboard removed. Place a dry cloth over the T-shirt and fix the ink by ironing it well for a few minutes on both sides. Set the iron at the highest heat suitable for the fabric.

RESOURCES

GENERAL

FRANCE

Couleurs du Quai Voltaire
3 Quai Voltaire
75007 Paris
Tel: + 33 (0)142 607215
www.magasinsennelier.com

UK

Kear Limited
Unit A5
Railway Triangle
Portsmouth
Hampshire
PO6 1TN
Tel: 08000 434617
www.artifolk.co.uk

USA

Dick Blick Art Materials
PO Box 1267
Galesburg
IL 61402-1267
Tel: 1 800 828 4548
www.dickblick.com

ACETATE

UK

Fred Aldous
37 Lever Street
Manchester
M1 1LW
Tel: 0161 236 4224
www.fredaldous.co.uk

CYANOTYPE PAPER, FABRIC

UK

Fred Aldous (see 'Acetate')

USA

Blue Sunprints
PO Box 13066
Vashon Island
WA 98013
Tel: 1 800 894 9410
www.bluesunprints.com

CYANOTYPE SOLUTION KIT

AUSTRALIA

Gold Street Studios
Ellie Young
700 James Lane
Trentham East
Victoria 3458
Tel: +61 3 5424 1835
www.goldstreetstudios.com.au

UK

Firstcall Photographic Limited
Cherry Grove Rise
West Monkton
Taunton
Somerset
TA2 8LW
Tel: +44 (0)1823 413 007
www.firstcall-photographic.co.uk

USA

Blue Sunprints (see 'Cyanotype
Paper, Fabric')

EXERCISE BOOKS

UK

Kidscorner
PO Box 2083
Rochford
Essex
Tel: +44 (0)1702 545154
www.kidscorner.me.uk

LIGHT-SENSITIVE FABRIC DYE

UK

Firstcall Photographic Limited
(See 'Cyanotype Solution Kit')

MESSENGER BAG

UK

Jungle Clothing UK
www.stores.ebay.co.uk/Jungle-Clothing-
UK-The-ARMY-Store

The Army Store
11-13 Wyndham Arcade
Cardiff
CF10 1FH
Tel: +44 (0)2920 343 141
www.thearmystore.co.uk

PAPER
UK
Intaglio Printmaker
9 Playhouse Court
62 Southwark Bridge Road
London
SE1 0AT
Tel: +44 (0)20 7928 2633
www.intaglioprintmaker.com

T N Lawrence & Son Ltd
Hove Retail Shop
208 Portland Road
Hove
BN3 5HR
Head Office, Mail Order & Warehouse
36 Kingsthorpe Road
Hove
BN3 5QT
Tel: +44 (0)1273 260260
www.lawrence.co.uk

USA
McClain's Printmaking Supplies
15685 SW 116th Avenue PMB 202
King City
OR 97224-2695
Tel: 1 800 503 641 3555
www.imcclains.com

PLAIN CUSHION COVERS, T-SHIRTS, SHOE BAGS, SHOPPERS, TEA TOWELS
UK
The Clever Baggers Ltd
Fox Buildings
Severn Road
Welshpool
Powys
SY21 7AZ
Tel: +44 (0)1938 530 050
www.thecleverbaggers.co.uk

RELIEF PRINTING BLOCKS, TOOLS AND INKS
UK
GreatArt
Normandy House
1 Nether Street
Alton
Hampshire
GU34 1EA
+44 1420 59 3332
www.greatart.co.uk

Intaglio Printmaker (see 'Paper')

The Art Shop
No. 8, Cross Street
Abergavenny
Monmouthshire
NP7 5EH
Tel: +44 (0)1873 852 690
www.artshopmaterials.co.uk

SCREEN PRINTING FRAMES, MESH, INK
FRANCE
Joop Stoop
12 Rue Le Brun
75013 Paris
Tel: +33 (1)5543 8995
www.joopstoop.fr

UK
Intaglio Printmaker (see 'Paper')

T N Lawrence & Son Ltd (see 'Paper')

SILK SCARVES
UK
GreatArt (see 'Relief Printing Blocks, Tools, Inks')

SOLAR PLATE
FRANCE
Joop Stoop (see 'Screen Printing Frames, Mesh, Ink')

UK
T N Lawrence & Son Ltd (see 'Paper')

ABOUT THE AUTHOR

Vanessa Mooncie is a contemporary crochet jewellery designer and maker, silkscreen artist and illustrator. She spent many happy hours as a child learning to crochet and knit with her mother and grandmother. She went on to study fashion and textile design, then became a children's wear designer, illustrator and commercial interior designer. She lives with her family in the English countryside.

She is the author of four books for GMC: *Crocheted Accessories*, *Animal Hats*, *And Sew To Bed* and *Crocheted Wild Animals*. She is also the co-author of *Tea Cozies 3*.

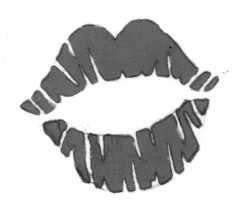

ACKNOWLEDGEMENTS

Thank you to Jonathan Bailey and to all at GMC Publications. I would like to give a special thank you to Dominique Page for being so scrupulous and supportive in the making of this book. I thank my husband Damian, my children Miriam, Dilys, Flynn and Honey, and my granddaughter Dolly for their endless encouragement.

I would like to dedicate this book to Emma Evans-Freke and Linda Felcey who inspired me to print.

The publishers would like to thank Julian Vilarrubi and Marion Charles for kindly allowing the use of their studio.

INDEX

GMC PUBLICATIONS LTD, Castle Place, 166 High Street, Lewes, East Sussex, BN7 1XU, United Kingdom
Tel: +44 (0)1273 488005. Website: **www.gmcbooks.com**